Ian Carr-Harris

Works : 1992 – 2002

© 2002 by The Power Plant
Contemporary Art Gallery at Harbourfront Centre
231 Queens Quay West, Toronto, ON, Canada M5J 2G8
(416) 973-4949
www.thepowerplant.org

--

National Library of Canada Cataloguing in Publication

Carr-Harris, Ian, 1941–
 Ian Carr-Harris: Works: 1992–2002 / curated by Philip Monk ; essays by Philip Monk and Antonio Guzman.

Catalogue of an exhibition held at the Power Plant Contemporary Art
 Gallery, Sept. 21 to Nov. 17, 2002.
Includes bibliographical references.
ISBN 1-894212-01-0

1. Carr-Harris, Ian, 1941– —Exhibitions. I. Monk, Philip, 1950– II. Guzman, Antonio J. III. Power Plant (Art gallery)
IV. Title.

N6549.C37A4 2002 709'.2 C2002-903988-6

--

The Power Plant
Contemporary Art Gallery

⊙ Harbourfront centre

Ian Carr-Harris

by **Philip Monk**

with an essay by **Antonio Guzman**

The Power Plant
21 September — **17** November **2002**

Works : 1992 — 2002

CONTENTS

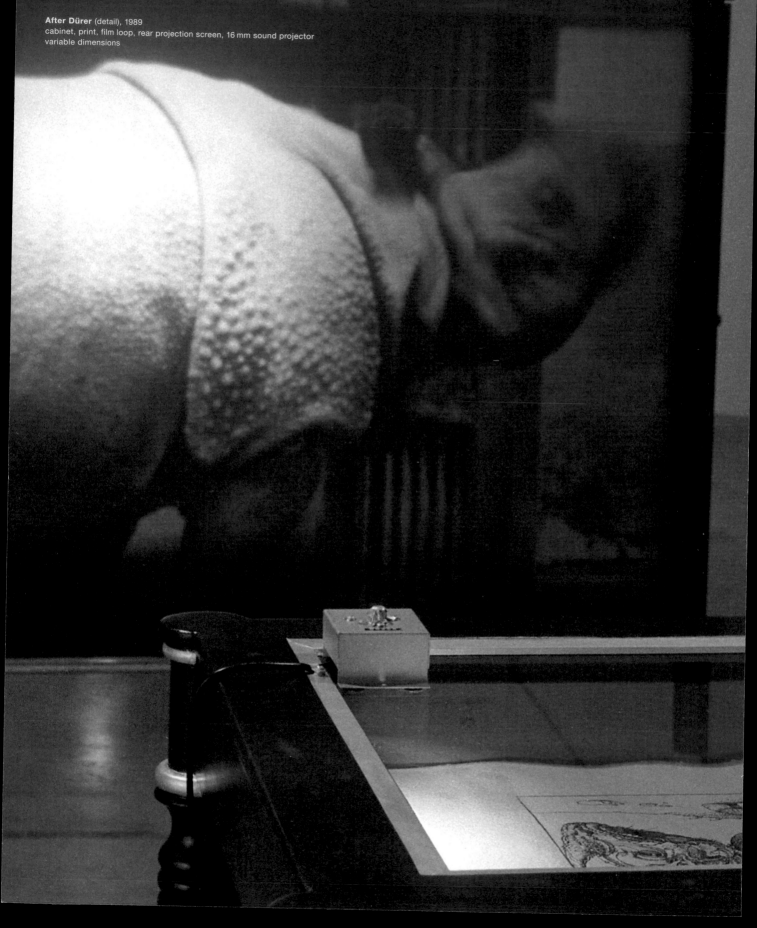

After Dürer (detail), 1989
cabinet, print, film loop, rear projection screen, 16 mm sound projector
variable dimensions

Deaccessionings

Philip Monk

Works : 1992 – 2002

*My work situates itself in that space we reserve for our recognition that the
histories and structures which we use to give definition to identity are them-
selves contingent and fluid, no less elusive than the identities we wish to secure.
Through shifts of emphasis, the work seeks to disturb our field of knowledge
while leaving it also apparently intact. Nothing has been factually changed, noth-
ing has been invented or promoted; it is simply that some insertion, perhaps
a footnote or a repetition, maybe an archaism, or just an object in a room, has
complicated the linear flow of anticipated narrative — and we realize, with an
atavistic pleasure, that we never are where we thought we were.*

— Ian Carr-Harris, 1993

*My work centres on acts of re-tracing — we could call it "re-touching" — con-
ceived as forms of demonstration. Events rather than objects, they require that
we look at something that we already "know," and in that looking to discover —
not quickly, nor entirely grasped — something we took for granted.*

— Ian Carr-Harris, 1997

Ian Carr-Harris

Preamble

Ian Carr-Harris makes works that pass for other things but are not quite. He makes sculptures that look like furniture but have no such function. He poses them in the gallery space, creating a theatrical effect, as if they were part of some occluded narrative that we are too late to experience. Somewhat precipitately abandoned perhaps, nevertheless these obdurate objects maintain an aura that makes our experience of them rather more of an event.

This exhibition is a survey of Carr-Harris's work of the past ten years, with the addition of an earlier piece, *After Dürer* (1989). *After Dürer* is exhibited separately from the other works here as a reminder of the artist's audiovisual installations of the 1980s, of which this piece marked the conclusion. It reveals a number of concerns that are constant within his oeuvre. Typical of that particular period, the installation exposes all its elements to view: cabinetry and audiovisual equipment, including speaker, projector and screen (all custom fitted by the artist). The cabinet houses a reproduction of the well-known print of an Indian rhinoceros by the German Renaissance artist Albrecht Dürer. A button on the cabinet, when pushed by the viewer, starts a film shot by the artist of a real rhinoceros at the Toronto Zoo. Between reproduction and reality an obvious discrepancy exists, but the work also points to other questions: How do schemas of knowledge impose themselves through representation on our experience of the world, and how does even imagination map convention onto our perception of it?[1]

These questions are posed within a theatre of demonstration, so to speak. An unusual classroom, this theatre of demonstration. Some might find the discourse delivered there dry and academic. However, in definition "exhibition" and "demonstration" amount to about the same thing, so the self-reflexivity of *After Dürer* dramatizes the conditions of presentation. Yet what Carr-Harris's works show and what they dramatize are two different things. The tables, cabinets and shelves that frequently reappear in Carr-Harris's work are not mere supports; they are implicated frameworks: they stage various scenarios. We might take these scenarios to be models or demonstrations, but, in effect, the tableaux they stage are allegorical, which, as Walter Benjamin wrote, "transforms things into stirring writing."[2] It might surprise us, then, to realize that the schoolbookish works in exhibition here seem preponderantly about ruin, loss and abandonment; they are memorial and melancholy emblems of allegory.

Index

A pile of books thrown on a flimsy card table hardly suggests the armature of an intellectual system. Yet, whenever a book appears in Carr-Harris's work, the whole system of the Classical order of representation and its project of the encyclopedia surfaces with it. Not only is the artist himself an art teacher, which perhaps explains the pedagogical bent of some of his art, but he is also an ex-librarian trained in larger systems of classification; so, bibliophile as well, he is also attentive to the

nuances of bibliographic inscription, to the vertiginous other world that footnotes, for instance, open for reflection, which a writer like Borges has fictionally exploited so well.[3] Both the colonializing arrogance of the grand schemes of knowledge and their obverse, the recessive domains of imagining that the Book opens to language, seem worlds passing, their shared episteme overthrown. The architectonics of the library system create a conceptual spatialization whose ruin as well can be represented. Here in *Index* (1993), as the tabletop tableau Carr-Harris stages, the upright statutes of the library are in disarray. Its surpassed systems and classifications, its dated forms of ordering knowledge, as if so many signs — even though the things themselves — divorced from their references, lie disposed for deaccessioning. Representative of the whole system, its indices are foreclosed and abandoned.

The title *Index*, gold foil-stamped on the institutional hard covers of the volumes, names the generic function of each book. More than a double functioning reference (it also names the work itself), the title refers to the disciplinary purpose of the book but also indicates, by way of the artist's staging, the fallenness of that enterprise. If the mnemonic system of the library seems in ruin, how are we collectively to remember, except repetitiously to retrace with our index finger the contours of an estranged inscription detached from its origins — as if, the ruins of an ancient civilization, the fallen columns of books with their obscure titles can only be looked at but not comprehended?

--
Made in Hong Kong
--

Our inability to put our finger on the precise meaning of any particular Carr-Harris sculpture, which appears so much like any commonplace object that we usually overlook, makes us pause during our nebulous encounters with these things to wonder, What are we looking at? When we turn a corner in the exhibition, we come upon two of these furniture-like sculptures theatrically but awkwardly disposed in the space. *Made in Hong Kong* and *Jan. – Mar.* (both 1993) look as though they have been abandoned, left half moved in a warehouse, as if their agents' activity was disrupted. Hanging in the trajectory of an action rather than embodied in a use, these sculptures beckon to us to complete their meaning. Perhaps instead these furnishings are half looted: two figurines and a pile of books remain in the large wall cabinet of *Made in Hong Kong*. The residue of their placement suggests a history, but maybe these objects have been abandoned by time itself. One can almost feel the dust settling in this twilight atmosphere as the objects are not only bereft of use but are slowly slipping from the ground of place and time as well. Are we, then, looking at an object or experiencing an event, a narrative act that includes ourselves?

The fragment of generic counter in *Jan.– Mar.* is separated from its architectural context as much as from whatever its commercial or bureaucratic function might have been; nevertheless, the pile of magazines left on its countertop oddly situates it spatially and temporally and adds a story of its own. Examining the counter, we discover no more forensic evidence of its history than a label on one of its drawers: "Jan. – Mar." it reads. The title of the work also designates some system of classification within it. This institutional categorizing of time differs from that which the seemingly abandoned pile of magazines might signify, so much is the latter at odds with its circumstances (who has left it?).

Ian Carr-Harris

Wrapped with packing tape like so many recyclables, the pile of magazines is as disposable as experience itself, whose lost time these mass market products can be seen to measure. Nonetheless, the pile secretly harbours within itself another history—that of past exhibitions. It is an index of the place and time of the work's various showings. Currently, a pile topped by an image of the ever topical Madonna from the sculpture's last presentation in America has supplanted the collection of porno magazines from Amsterdam's red light district, where it was previously exhibited in 1994. The artist has thus made the moment of the work's exhibition a component of its construction. This temporal embeddedness persists, like a snapshot, when the work travels to new exhibition venues. With every exhibition, the work inhabits two moments of time: that of our "actual" experience, and that of a displaced fold in time that opens to incorporate us as viewers.

What if this opening also subtly disincorporates us? Carr-Harris has said that he is interested in objects for their surrogate relationship to us. A surrogate relationship makes these things, thus, more than objects, if we think of an "object" as a thing that we behold or conceive before us, whose relationship to us is completely determined by this looking. The pile of magazines has a strategic role to play in establishing another relationship. The surrogate nature of the counter on which it rests— although fabricated by the artist, it simulates a ready-made placed in a gallery space—already brings us up short before it. By "surrogate," however, Carr-Harris does not merely indicate the substitutive or mimetic character of his sculpture. What is real, lying upon it—the pile of magazines—catches us unaware, perhaps inducing an unexpected and out-of-place, mild erotic frisson in us. This sensation would have been more obvious in *Jan. – Mar.*'s Amsterdam presentation, a condition that persists, however, in a like functioning work *1-(900) 999-6969* (1991), a roughly constructed counter similarly with another pornographic magazine on top of it. The surrogate relationship Carr-Harris wishes to establish is that of another *body*, which makes sculpture an erotic as well as a rhetorical discourse.

Captured by the look of the work—its gaze, so to speak—we are caught in the specular image of our desire. This mirror image repeats our appearance, so caught, in the gaze of others in the gallery space, ourselves possessed and dispossessed at the same time. "The speculary dispossession which at the same time institutes and deconstitutes me is also the law of language," and the deferments of temporality, we might add.[4] The semantics of tense "embodies" this for us, positioning us temporally through language, repeating our self-possession standing before the work as object. "It would seem that we are situated to a great degree by tense: past, present, and future," Carr-Harris has written, thus seeming to confirm our uncomplicated though obdurate relationship to these sculptures in the present tense of our experience. As we have seen in *Jan. – Mar.*, this ontological relationship is not so simple but carries within it the trace of otherness that solicits yet denies self-presence or auto-affection.[5] Drawing from Jacques Derrida's notion of the trace, the artist noted a contrary "insistence in the trace on the *instability*, the *contingency* of the present, on the fluidity of the tense— *under tension*—in which the past and the future merge in the determination of 'that which is to have been traced.'"[6] That which is to have been traced will be the pre-figuration of our desire.

Made in Hong Kong and *Jan. – Mar.* belong to a series of works that, according to Carr-Harris, employ "familiar objects to demonstrate the paradox of objects: that their very concreteness is dependent on their transformation over time." The artist has also said that he is "fascinated by the indeterminacy of sculpture's borders, the fact that our experience of sculpture is very fluid—it's not about a fixed

image." The interlacing of a paradoxical temporal transformation and indeterminate spatial borders takes place in our engagement: we are the indexical pronouns—the "you" or "I"—filled by the moment of the work's address. Thus, both sculpture and spectators themselves are open to flux, to narratives, sometimes (subjectless) "memoirs," that only partially coalesce in momentary conjunctions. In these touchings, we experience the object, not its function or reference, but itself anew. Nothing ersatz, as if made in Hong Kong, but an advent.

8, rue Ferrand

Not even an object, but an event—such would precisely describe a class of works Carr-Harris periodically produces. For example, *8, rue Ferrand* (2002) is made from only the slightest, but most dramatic, of theatrical materials—light itself. This light projection is one of several Carr-Harris has created that artificially re-enact the passage of sunlight through time across a particular space: here a hallway in an art school in Valenciennes, northern France, where the artist exhibited in 1995. A specific space is recreated by the merest tracing of light cast artificially from a projection mechanism that the artist manufactures. The space is recreated in one of two ways: more typically, as in *231 Queens Quay West* (1998), where it replicates a natural play of light that has been occluded on its own site, for instance, where the windows have been walled over for art gallery purposes; or, as in *8, rue Ferrand*, where it is displaced to and originally shown in another locale.[7]

Our experience is hardly modified as we pass through the installation of *8, rue Ferrand* at The Power Plant. We are touched only in the most ambient fashion by a play of light that proceeds in its slow pace without us. At the same time, though, we are divided, because of a dislocation fundamental to the work, between the "here" of The Power Plant and the "there" of the address of the title, and between the "now" of our experience and the "then" of a moment of the past that has been reproduced for us. Neither the shining itself, nor our memory of it—therefore neither a presence nor an absence—this play of light rather is a mnemonic fiction. It is produced as a reproduction, sustained in a mechanical repetition that originally divides both it and our experience of it in every instance of its presentations. Memory is only a succeeding trace of each of these fundamental divisions.

Narcissus

The engraving: *art being born of imitation only belongs to the work proper as far as it can be retained in an engraving, in the reproductive impression of its outline. If the beautiful loses nothing by being reproduced, if one recognizes it in its sign, in the sign of the sign which a copy must be, then in the "first time" of its production there was already a reproductive essence.*

—Jacques Derrida[8]

Ian Carr-Harris

It is not, therefore, for its metaphoric indeterminacy that light seems to play such a large role recently in the artist's work. On the contrary, in the back-lit book works, such as *Books of Knowledge* (1992–) and *Encyclopedia Britannica; a new survey of Universal Knowledge. Chicago, University of Chicago, 1944* (1996–), its use is quite pointed. In all these book works presented splayed open, where a plate faces the text it illustrates, light cuts out a detail from a photo-engraved image. For example, in *Narcissus* (1994) backlighting highlights the head of a narcissus flower. Light's function is to illustrate the illustration, to illuminate it, so to speak, as the dictionary defines one of illustration's meanings. If the encyclopedia seems the embodiment of Enlightenment rationality (with all its metaphors of the light of reason), light here, rather than being illuminative, takes on a disruptive function. In the artist's words, it becomes "a vertiginous element within the intimate act of reading." Light turns the image into even more of an emblem, making of the ensemble of image and text an object to be looked at rather than read. Framed within the frame of the vitrine that *Narcissus*'s table constructs, the book lends itself to a sensory, not readerly, experience. Detached from the literary, its glow, all the same, may induce a reverie of loss suggestive of the myth of Narcissus.[9]

Nevertheless, within this mythic garden of the origin of desire — no matter how spontaneously sprung that act may seem to be — we discover a "reproductive essence." In retouching the image, light in effect doubles it, separating the image from its original imprint. A replicative act is inserted into an already reproductive medium. The book may seem only illustrational, yet it symbolizes the archive of culture. Not only in the subjects and forms of their classification, these photo-engraved images have the look of the nineteenth century about them: they are already images of images, hence an imaginary museum. The presence of the book *and* print together places such works within the mutually reinforcing discourses of the library and museum, archival discourses that are already inscribed by the reproductive technologies of these media, no matter if these institutions are dedicated to the artifacts of individual genius. Reproduction makes the repository and what comes before as tradition housed in these institutions part of a process of repetition to which pedagogy presses the individual to conform. The origin of desire is another's invention that we repeat according to the "statutes" we find in books or the "book" of our culture. Culture is pedagogy. So like schoolchildren, we trace and retrace the lineaments of our desire in the image of an other.

Molly

"Pedagogy cannot help but encounter the problem of imitation."[10] So another class of Carr-Harris's work is the blackboard of the type found in elementary school rooms. If the subject's position is grammatical, here is one of the institutions of its inscription. As if they are so many examples of orthography and proper penmanship, the artist emblematizes in script components of this constitution on the blackboards of the collective series *Language* (2001–), with its individual works with subheadings "Writing: noun," "Writing: verb," "Writing: subject," "Writing: object," etc., thus reproduced. But in *Molly* (2002), he offers a perverse object lesson of writing with no punctuation. In fact, the text to *Molly* repeats the last lines of one of the monuments of high modernism: James Joyce's *Ulysses*, an unusual choice for such pedagogical discipline. If our "detention" was indefinite enough in our copying of lines, we might reach the beginning of this example with its echoing "yes" that

commences Molly's monologue and is repeated by the reaffirmative "Yes" at its end here, the last word of Joyce's text.

In between, the "yes" is relayed many times, and in Carr-Harris's reiteration — "and then I asked him with my eyes to ask again yes and then he asked me would I yes to say yes my mountain flower and first I put my arms around him yes and drew him down to me so he could feel my breasts all perfume yes and his heart was going like mad and yes I said yes I will Yes" — each "yes" is emphatically highlighted by backlighting. If in turn we say yes, write "yes" to the text that advertises this word to us, what example has it given us? Thus the problem of any pedagogical lesson: are we learning by rote or by heart?

Beyond its purported lesson, does the "yes" in *Molly* carry another value for the artist, confirmation of its affirmation, that speaks of the desire of the artist through the words of the character, the expression of her heart? Does it recall some reminiscence the artist wants to affirm through the substitution of the feminine evocation here? Yet the word "yes" is many things when it "is written, quoted, repeated, archived, recorded, gramophoned, or is the subject of translation or transfer," as it is in *Ulysses*. "In order for the *yes* of affirmation, assent, consent, alliance, of engagement, signature or gift to have the value it has, it must carry the repetition within itself. It must *a priori* and immediately confirm its promise and promise its confirmation. This essential repetition lets itself be haunted by an intrinsic threat, by an internal telephone which parasites it like its mimetic, mechanical double, like its incessant parody."[11] Like its lesson retraced here.

--

Annabel

--

Evoked through the name of another female, once again reveries of temporal passage and loss are foremost but even more improbably expressed in Carr-Harris's *Annabel* (1999). In this twelve-minute audio work, the MAC computer voice, Fred, reads excerpts from Vladimir Nabokov's 1955 novel *Lolita* on the nymphet precursor to Lolita, the said Annabel. *Lolita* is written in an overwrought style: "You can always count on a murderer for a fancy prose style," the pseudonymous author (Humbert Humbert, not Nabokov) opines in his reminiscences of Annabel. Such a statement signals Nabokov's mimicry of the literary models that effect the voice of his narrator — both his style and his desire or, rather, the style of his desire. It alerts us both to the role of culture in the formation of affect and the subject's predication in language. Famously, Emma Bovary's affair is written already by the Romance novels she consumes. If the subject's position is of grammatical origin, what of the disembodied, uninflected and unanimated voice of *Annabel*? An entity with no subject (the computer) "reads" the prose of a carefully constructed fictional entity who is confessing, intimately but with an ear to style, his obsessions. A mechanical memory, moreover, merely covers this writing by reading over it; its reminiscences carry no affective value. Yet, strangely, the banality of the voice and the irony of the overwrought writing seem to cancel each other, leaving as essence — or, same thing, trace — a strange mix of longing and loss.

"The desire for memory and the mourning of *yes* set in motion the anamnesic machine. And its hypermnesic overacceleration. The machine reproduces the living, it doubles it with its automation."[12] Does Carr-Harris lament this more fundamental loss than that of living memory — the giving way to the automaton? Or as for Humbert's near contemporary Krapp, the protagonist of Samuel Beckett's 1958 play *Krapp's Last Tape*, does the trace machine become the archive of the disavowed or forgone pleasure, a melancholy reminder of and model, in fact, for the absence of plentitude?

--

Conclusion

--

Within the divided trace of the already inscribed, Carr-Harris's works register a double movement: on the one hand, they present themselves as a falling away and disinvestment of the sign from an absent referent (an original plentitude or an always already deferred reproduction/repetition?), which, on the other hand, leaves in its place a trace that is doubled or retraced in our abandonment by our retouching (a consolation or a constitution?). One does not succeed the other: fallen thought is memory trace, or, rather, each is inscribed in the other as this double movement.

This movement can be read in the change from Carr-Harris's early work that this exhibition marks. Compare *After Dürer* to the differing works in the exhibition that succeed it. In *After Dürer*, the spectator is asked to match the representation of the print against the so-called reality of the film image and to realize the gap between these constructions. In the succeeding works, representations now only call forth other representations in an infinite regress, never settling in reality: a book refers to a book of books (the Index), which refers to the library, which refers to the Book of Knowledge of the universe, etc. Do we lament this infinite deferment of the referent, or in some way take pleasure in the indices of its mediate touchings?

Carr-Harris's lesson is not a sad one. If we are to believe autobiographical reference, it can become a joyful science. Relating the story of his seven-year-old self tracing a comic book image against a sunlit window, the artist confesses, "What I came to realize was that no subsequent experience, no amount of exercising 'originality,' no amount of making 'something new' had ever touched me so deeply, excited me as much, as that discovery of the 'trace.'"[13]

Notes

1. Within this comparative apparatus, Carr-Harris does not assert the new realism over the old: both are representations.

2. Walter Benjamin, *The Origin of German Tragic Drama*, trans. John Osborne (London: NLB, 1977), 176.

3. The closed rationality of the library opens a world to the imagination; see Michel Foucault, *The Order of Things* (New York: Random House, 1970) in general and his essay "Fantasia of the Library" in particular [*Language, Counter Memory, Practice*, trans. Donald F. Bouchard and Sherry Simon (Ithaca: Cornell University Press, 1977)]. The precursors of Carr-Harris's back-lit illustrated books were table works of footnoted books and sculptural assemblages, such as *The Anchor Bible. Judith; a new translation with introduction and commentary by Carey A. Moore (Garden City, N.Y., 1985), 23* and *McClung, Nellie L. Clearing in the West: my own story, Toronto, 1965), 286* (both works 1988) that used fictional footnotes as counter-arguments or counter-inscriptions of possible worlds.

4. Jacques Derrida, *Of Grammatology*, trans. Gayatri Chakravorty Spivak (Baltimore: The Johns Hopkins University Press, 1976), 141.

5. On the trace, touching and otherness, see Derrida, *Of Grammatology*, 165: "The possibility of auto-affection manifests itself as such: it leaves a trace of itself in the world. The worldly residence of a signifier becomes impregnable. That which is written remains, and the experience of touching-touched admits the world as a third party. The exteriority of space is irreducible there. Within the general structure of auto-affection, within the giving-oneself-a-presence or a pleasure, the operation of touching-touched receives the other within the narrow gulf that separates doing from suffering. And the outside, the exposed surface of the body, signifies and marks forever the division that shapes auto-affection."

6. The artist continues, developing the idea that will influence the future course of his work in the direction of reproduction, repetition or iterability: "Further, this instability — it seems — precludes the possibility of singularity. Why? Because under the sign of trace there is an expectation, a logic of momentum or mobility which draws us, we could say, to trace that which we anticipate having revealed not once, but a thousand times — an insistence that is even *infinite* in its proportions or quantifiability — as completely

invested in the necessity of repetition as it is dis-invested in the possibility of singularity." Quoted from an unpublished 2002 lecture by Ian Carr-Harris entitled "Tracing Reading Writing," n. p. All further quotations by Carr-Harris are taken from notes on work accompanying the artist's exhibitions.

7. Yet even the first type of projection might travel to another locale, such as when *137 Tecumseth* (1994), the address of the title referring to the Susan Hobbs Gallery in Toronto where the work was first exhibited, was shown subsequently in Montreal.

"I am unable to discuss the varied issues of titles in Carr-Harris's work. Suffice it in its particular instance here to quote the artist: *Rozenstraat 8, Part 1* (1995) "rehearses the 'Nature' of address, the address addressed to itself. The representation of sunlight (an original or 'natural' projection) modified by the 'address' itself (the windows at Rozenstraat 8), constructs for us our sense of the real. To this reality we can apply with some assuredness a name: Rozenstraat 8. Yet the name itself is a mirror, as the projected light is a representation, both standing for that textual identity we call Nature."

8. Derrida, *Of Grammatology*, 208. The epigraph by Derrida is not fortuitous given that Carr-Harris has cited it a number of times in lectures and notes.

9. As Derrida has so often emphasized, repeated outside the work, at its edge, the title is also a scission within it, an abyssal mirror that unfounds any identity, like that of the mirror image that captivated Narcissus. The title of Carr-Harris's work *Narcissus* repeats the caption to the image of the Narcissus flower. But to what complex of references does it refer, when we glance at the text that the image illustrates: "Narcissus," a genus of plants; "Narcissus," a Greek mythological character; or "Narcissism," a psychological disorder? The title is one more repetition that enters back into the work to confound it in its infinite reproducibility.

10. Derrida, *Of Grammatology*, 204.

11. Derrida, "Ulysses Gramophone: Hear Say Yes in Joyce," *Acts of Literature* (New York, London: Routledge, 1992), 266, 276.

12. Ibid., 276.

13. Carr-Harris, "Tracing Reading Writing."

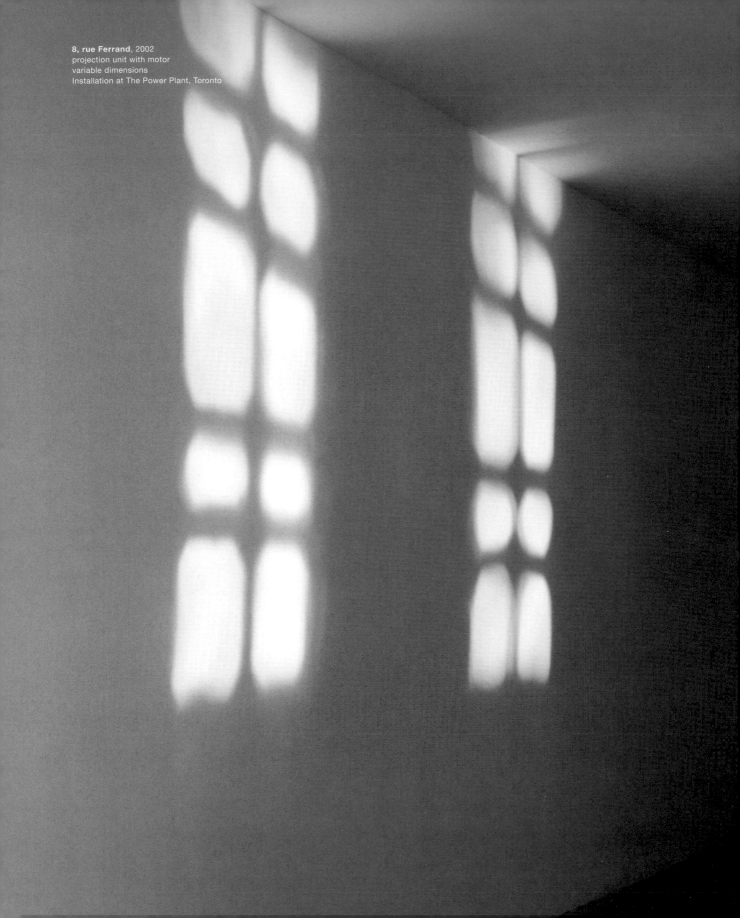

8, rue Ferrand, 2002
projection unit with motor
variable dimensions
Installation at The Power Plant, Toronto

Le temps d'Annabel à Lolita

Antonio Guzman

--
Mehr Licht (plus de lumière)
--

Cela ne se fait probablement pas de commencer quelque chose par la fin d'autre chose. L'esthé-
tique et l'histoire, comme la critique de l'art contemporain, ne manquent pas de textes essentiels
et anthologiques pour situer le début d'une étude sur la création plastique d'un travail encore
en cours comme celui d'Ian Carr-Harris. Les archives diverses comme les utopies et les mémoires
différentes de l'art seraient suffisamment riches pour fournir une autre entrée en matière, d'autres
prétextes, d'autres pirouettes savantes et érudites, à propos du travail d'un artiste vivant peut-être
plus appropriés que les derniers mots d'un poète mourant.

Autant l'avouer; depuis qu'il m'incombe ces jours-ci de réfléchir à l'activité artistique d'Ian Carr-
Harris, je ne me défais pas de ces derniers mots, de cette exclamation extrême, possiblement
apocryphe, de la figure faustienne de Goethe en 1832 à Weimar. A défaut alors, entre le canonique
et le suspect, *Mehr Licht* peut servir de devise pour aborder deux ressorts qui sous-tendent le
travail d'Ian Carr-Harris et qui sont la lumière et le langage.

--
le travail de la lumière
--

Dans le contexte des productions qui concernent cette exposition et cette publication couvrant
le travail d'Ian Carr-Harris pendant les années 1992–2002, la lumière est utilisée de deux façons
différentes, comme matériau et comme médium.

Dans le cas de la lumière utilisée comme matériau, celle-ci est tout ce qui reste du lieu cité dans le
titre de l'oeuvre en question, *8, rue Ferrand* (2002), où l'adresse est devenue une toponymie. Selon
les termes de la simulation, cette lumière serait solaire, mais elle est en effet incolore, abstraite,
neutre, sans matière et sans valeur chromatique ou indice thermique, sans saison. Elle est la dernière
présence, l'aboutissement pénultième d'un processus de dématérialisation, d'effacement et de
débarras d'un espace ayant domicile à l'adresse du titre. Si la lumière qui entre par les fenêtres
venait à s'éteindre et ne reprenait plus son cycle diurne-nocturne, il ne demeurerait dans la place
que le dispositif machinique de projection, le cyclopéen projecteur.

Avant-dernière épure d'une démarche de clarification, comme dans les oeuvres intitulées *137
Tecumseth* (1994), *231 Queens Quay West* et *2, rue des Deux Moulins* (toutes les deux de 1998),
la lumière ici survit à l'élimination des propriétés des volumes, des couleurs, des textures, des
objets et des anecdotes de l'espace en référence. Autrement, dans ce drame de la disparition de
la troisième dimension, où les corps et les choses du monde se tiennent, la lumière garde mélan-
coliquement en elle des rapports de proportion et d'échelle à l'espace d'origine vraisemblables.
Topographiquement, la profondeur de la portée de sa projection, le tracé de sa forme, le cours de
sa trajectoire temporellement raccourci simulent toujours ceux des fenêtres du site disparu, des
ouvertures à la lumière naturelle lorsqu'elle entrait encore dans l'espace, alors qu'il existait encore

lui-même, avant qu'il ne soit évidé et abstrait, la lumière artificielle étant désormais le seul élément de représentation spatiale, la dernière lueur de l'architecture et du bâti, sans maçonnerie.

En cela le travail d'Ian Carr-Harris est presque aussi ludique et simple qu'un jeu enfantin de *lanterne magique*, aussi économique qu'un *théâtre d'ombres*, qui ne nécessitent qu'une source de lumière et un écran pour que tout ce qui passe entre ces deux éléments projette une ombre sur l'écran. Ce qui diffère et complique ici, entre autres développements, c'est que ce sont des fenêtres qui sont figurées, des images-lumière, des sources lumineuses qui sont passées devant la source lumineuse qui n'est désormais qu'un projecteur customisé et électroniquement programmé. Entre fait et feinte, les fenêtres et la lumière sont aussi dématérialisées que le reste; la lumière ici n'est plus que l'ombre rayonnante d'elle-même, une ombre parmi tant d'autres dans des oeuvres où c'est l'ombre qui fait question.

le travail de l'ombre

Seule ouverture qui subsiste dans des oeuvres autrement encloses, sans flamboyance et sans incandescence, cette lumière a toutefois une part d'ombre; de fait, il ne pourrait guère en être autrement. C'est la pénombre des galeries où ces oeuvres sont exposées qui sert de cadre, de base et de fond pour la lisibilité de la projection, qui revient et qui rythme les cycles d'émergence et d'évanescence lumineuse. De même c'est l'ombre qui donne relief, modelé, dessin et trait aux châssis des fenêtres; tout ne pouvant être qu'un plat éblouissement aveuglant, ni ici, ni ailleurs. (*Mehr Licht. Plus de lumière*).

Qu'est-ce que cela peut signifier que de tout évincer et de tout extraire, en ne laissant qu'une seule aperture calibrée pour l'entrée de la lumière diurne? Ian Carr-Harris sait bien que c'est une décon-struction et une prévision, une démarche à reculons et à rebours, où tout du monde est envoyé dans l'ombre pour mieux laisser faire le travail de la lumière; davantage, il sait que cette déconstruction est corrolairement une construction, celle d'une *camera obscura*.

Avant le *velum* d'Alberti et aussi avant la vitre de Dürer, mais comme eux, la fonction de cette chambre noire est d'organiser le regard, à l'abri du flux du réel. Comme d'après ses notes pour la première exposition de *137 Tecumseth* à la Susan Hobbs Gallery en 1995, Carr-Harris sait ce qu'il manipule avec ce modèle du regard; que c'est toujours une affaire d'ombre et de lumière, et de ce qui est laissé dans l'une ou dans l'autre. Cela était déjà le cas lorsque, semble-t-il, l'astronomie arabe dès le 11è siècle se servait de la camera obscura pour observer les éclipses du soleil, ce phénomène astral où la lune interpose sa sphère devant le soleil et projette un pic de cône d'ombre sur la terre; on regarde de manière détournée ce que l'on ne devrait pas voir de face, on s'arrange pour mieux voir, indirectement. C'est dans l'ombre que l'on regarde la lumière; dans l'ombre, le cas échéant, que l'on demeure à l'éclipse de la lumière.

Dans cette affaire, c'est l'ombre qui fait le travail d'abstraire le monde et la lumière celui de le porter et de le représenter. On obscurcit pour mieux éclairer.

Ian Carr-Harris

l'espace d'ombre et de lumière

Il faut quand même des parois pour bâtir une camera obscura, pour la fermer à la lumière, enfermer l'ombre, pour créer un dedans et un dehors, un ici comme un ailleurs, et enfin pour ouvrir l'orifice qui serait un *oculus*. C'est ainsi que la camera est une structure et un lieu du regard, une construction opérationnelle et l'architecture close d'un vide, dont la métaphysique aboutit à un regard qui voit mieux parce qu'il est détourné, focalisé, sans distraction, distancié, pour avoir littéralement quitté le monde et lui avoir tourné le dos. Foyer et logis de l'image portée et projetée sur la paroi opposée à l'aperture, ce serait une métaphore, une chambre de la conscience, une antichambre de la connaissance.

Cela se comprend qu'il faille une *ligne d'ombre*, pour la partition, pour dépareiller, pour isoler les zones et séparer la lumière de l'ombre, pour reconnaître l'une de l'autre; une *ligne de partage* pour découpler, démarquer, délimiter. Tandis que regarder est déjà une recherche d'un double, Carr-Harris dédouble ce processus lorsqu'il enferme un intervalle dans le flux du réel, lorsqu'il ouvre un interstice dans le cours des choses, pour mieux sélectionner et étudier l'objet du regard. Par delà, il multiplie ce dédoublement quand il simule dans ses projections de *137 Tecumseth* et de *231 Queens Quay West* la lumière des vraies fenêtres obstruées, réellement occultées, de la Susan Hobbs Gallery et du Power Plant, soulignant davantage au passage leur enfermement propre en tant que lieux d'exposition et de monstration plus qu'il ne les ouvre de nouveau à l'extérieur. A plus d'un titre, ce sont des espaces bâtis d'ombre et de lumière.

Qu'en est-il lors que Carr-Harris retourne ces oeuvres à l'endroit d'où il les avait prélevées? Ou quand il les présente dans d'autres locaux? Dans les deux cas il complexifie le dédoublement à des degrés différents; projection d'une représentation spatiale de retour dans l'espace dont elle serait la représentation spatiale, dans le premier cas; ubiquité, être dans la lumière d'un lieu et à l'ombre d'un autre à la fois, une représentation transposée, en décalage de son lieu de présentation, dans le second; et restauration de la troisième dimension auparavant prélevée dans les deux cas. Ce sont des projections de distance physique et figurée, dans les deux cas, quelque soit la proximité, deux dépendances pariétales des mêmes ou d'autres murs car l'objet du regard dans ces oeuvres qui sont des chambres noires c'est l'espace, l'espace intérieur des lieux d'exposition et de monstration. C'est l'aboutissement d'une autre démarche de prévision et de prévisualisation à rebours que cet engagement d'un palimpseste, où l'inscription postérieure laisse toujours apparaître l'inscription antérieure, où l'on peut lire l'ancien sous le nouveau, sinon inversement. Et la métaphore d'une dislocation sur place est bouclée, le début revient à la fin, étant projection et écran de lui-même, distance et proximité simultanément.

C'est en connaissance de cause que Carr-Harris fait recours au fonctionnement et à la métaphore de la camera obscura. C'est l'engagement d'un espace dégagé, séparé, du regard retiré qui se retourne vers là d'où il vient; où l'oeil et la camera servent de modèle l'un pour l'autre. Parce que vide, l'espace intérieur de la camera serait impassible, objectif, impersonnel, censé mieux donner à voir la véritable échelle, perspective et forme des choses, mieux exposer leurs vraies couleurs et leur véritable représentation.

Phénomène optique naturel, la lumière porte réellement l'image d'un objet extérieur sur le plan intérieur de la camera. Sans autre intervention et sans autre interprétation, c'est l'objet qui donne sa propre image et celle-ci serait une image spontanée et de surcroît naturelle; dans la camera, lieu de recul, le monde se mue en image et sacrifie la troisième dimension qui est celle de l'expérience; l'image du monde se reporte et s'y crée d'elle-même; ce faisant, le monde s'y répète et se remémore de lui-même.

Cette notion de répétition du monde par lui-même participe aux motivations du recours que Carr-Harris fait à la camera, une notion de réitération qu'il revendique pour son oeuvre comme en témoignent ses fréquentes notes de travail au sujet du dédoublement. Et pourquoi il précise et l'oppose à la pratique du *diorama* où, comme son étymologie l'indique, on voit à travers l'écran, où l'on regarde ce qui est vu en deux temps selon deux éclairages différents, tantôt frontal, tantôt dorsal, tantôt avant, tantôt après, ou selon une graduation des deux éclairages. Comme dans les tableaux de Daguerre et de Bouton à Paris aux années 1820, dans le diorama il s'agit de la même image réalisée deux fois, au recto comme au verso, pour être vue par effet de transparence ou par opacité. Mais les deux temps, diurne et nocturne, les deux surfaces peintes, les deux images obtenues des deux éclairages du diorama n'en font pas une affaire du double; il y est bien question de lumière, mais cependant pas d'ombre, ni de distance.

L'image du diorama est illusionniste, spectaculaire, mais sans métaphore; celle de la camera est naturelle, mais spéculaire. Si le propos de ce travail n'est point illusionniste, si tout ceci n'est pas un tour de passe-passe, c'est parce que cela serait un autre sujet, traitant des erreurs de la perception causées par de fausses apparences, du trompe-l'oeil, alors qu'ici c'est de la simulation qui ne cache pas ses artifices et qui ne trompe personne. Illusion d'optique n'est pas phénomène optique. La camera obscura, même simulée comme celles de Carr-Harris, est affaire de naturel, de réel, de contigu. Surtout, l'illusion n'a pas de mémoire, ce dont serait dotée la camera ou du moins les métaphores qu'elle engendre. N'ayant pas de mémoire, l'illusion ne peut pas ici être le propos; elle relève de l'*imitatio*, elle est effet et artifice, ne répète pas les choses, ne les revisite pas.

Comme l'écho, l'image voyage dans la camera et le faisceau lumineux qui la transporte et la transfère est une mesure, parmi d'autres, de la distance parcourue. Contiguë, circonstanciée et contingentée, comme l'écho l'est d'une source et d'une origine restées ailleurs et à distance, l'image possède une netteté diffuse et une permanence instable; éthérée et éphémère comme le son qui

nous parvient à travers le temps et l'espace, floue, cette image a valeur d'une dialectique, d'ici et d'ailleurs, d'autrefois et de maintenant, de présence et d'absence. C'est dans ce sens qu'elle a également valeur d'une réminiscence, d'un retour et d'une récognition.

le travail de la lumière, bis

Dans une oeuvre comme *Narcissus* (1994) le travail de la lumière est celle d'une relecture. Éclairage dorsal d'une page de planche d'illustrations, la lumière dans une oeuvre comme celle-ci a une fonction éditoriale, d'emphase par redondance et par tautologie : elle enlumine l'image qui illumine déjà par illustration le texte. La lumière rehausse l'illustration, la recolore; elle fixe et focalise le regard sur l'image qui serait le double visuel du texte, qui l'iconise. On doit en être lucide; on orne de lumière ce qui orne d'images; l'éclaircissement ici est illustratif, explicatif.

Relecture, sans autre apport que la lumière, de ce que nous avons déjà lu ou vu quelque part, de ce que nous savons déjà; la lumière remémore ici, elle est une forme d'anamnèse et de translation visuelle, éclairant par derrière une planche qui commente et se réfère au texte de la page opposée. Elle montre et démontre. Dans *Narcissus*, elle pointe la fleur tandis le texte traite d'autres sens du terme de l'image, ceux du stade psychique et de la névrose, comme celui de la figure mythologique qui, épris de lui-même se perd dans le regard de son reflet au point de ne jamais connaître l'amour charnel de l'autre, jusqu'à en mourir et être changé en une fleur qui porte son nom.

Ce choix de mise en lumière de *Narcissus* est également significatif du thème récurrent du double et de la répétition que Carr-Harris développe. Dans le mythe, c'est déjà et encore une histoire de dédoublement et de réitération: Narcisse se *re*-connaît dans sa *réflexion*, en est amoureux mais il ne peut pas tenir son fluide image aquatique dans les bras, pas plus qu'il ne peut se donner à l'autre; et Écho, la nymphe qui le poursuit, étant privée de sa voix par Héra et condamnée à ne jamais pouvoir initier la parole, à ne plus jamais prendre une parole qui serait la sienne, est destinée à toujours *re*-pondre, à toujours *répliquer* à l'autre; elle périt de son chagrin d'amour pour Narcisse, perdant chair et os jusqu'à ce qu'il n'en reste que sa voix, en attente d'une voix originaire, d'ailleurs, et dont elle n'aura toujours que le dernier mot.

Narcissus n'est pas une oeuvre isolée dans la production de Carr-Harris de ces dernières années; au contraire, elle est un exemple de plusieurs séries faisant usage de la lumière pour signaler et réitérer la planche d'illustrations d'un livre. Parmi ces séries, on peut compter celle des *Tafel* (1999), celle des *Books of Knowledge* (1992–), de l'*Encyclopedia Britannica* (1996–), de *Pays et Nations* (1997), toutes des séries entamées depuis une dizaine d'années et faisant recours à la *retouche* lumineuse dorsale d'un livre modifié. D'autres oeuvres, comme *McClung, Nellie L.* et *The Anchor Bible. Judith* (1988), rehaussent par la lumière un passage particulier du texte, et en font une citation; et *citation* encore au sens d'emphase par la répétition, le rappel et la convocation d'un texte déjà paru ailleurs.

Si l'on reste encore un peu sur le motif de la lumière dans la production récente de Carr-Harris, on s'aperçoit qu'il a fait des *enluminures* de ces oeuvres livresques. Comme le recours à la camera

obscura, cet emploi de la lumière est à son tour la citation d'une autre technique classique de l'histoire de l'art, aussi antiquisante et archaïque; la lumière peut bien être fluorescente, les planches imprimées et le livre mécaniquement broché, mais la parenté de ces oeuvres est dans la longue lignée de manuscrits et de miniatures d'avant Gutenberg. Aussi décoratifs et ornées que les bibles, psautiers, et bréviaires qui sont leurs modèles, ces oeuvres distinguent, comme les enluminures médiévales, la part du *pictor* de celle du *scriptor*, comme elles rappellent également que les enlumi-nures furent pendant des siècles l'ouvrage de *copistes*. Ce faisant, avec ces *livres d'artiste*, où un texte peut en lire un autre, Carr-Harris pointe l'écart problématique dans le rapport texte-image, lorsque l'on voudra que l'iconographie soit l'allégorie visuelle de l'écrit et sa transcription.

Ut pictura poesis

Si l'on considère le travail d'Ian Carr-Harris plus en arrière que le cadre de cette exposition et de cette publication, jusqu'à 1971 par exemple, on constate qu'il a usé de lumières différemment référencées au long de ce parcours avant de se servir de la camera obscura: photographie, cinéma, télévision, éclairage d'étalagisme publicitaire, éclairage scénique et simples lampes de lecture. Par la même occasion, on constate que le langage précède l'emploi de la lumière comme matériau ou comme médium dans ce parcours et combien le langage en est tout autant, si non plus, un motif et un moteur.

Par le passé le langage est apparu dans le travail sous forme de texte tapé à la machine, texte coulé en fonte, texte encadré ou texte typographié par lettraset. Suivant la même polysémie, le langage imprimé est introduit sur des supports variés: sur bristol, sur photographie, sur film, à même la surface d'une table, gravé sur papier. Aujourd'hui toujours, comme dans plusieurs oeuvres traitées à cette occasion, la présence et l'emploi du texte persistent. Comme la lumière, l'écrit imprimé est un matériau et un médium du travail. Après Babel, tantôt titre ou inscription ou enseigne, *pré*-texte ou *con*-texte, tantôt exergue ou détail, le textuel dans le travail de Carr-Harris lui confère une lecture double, entre le lisible et le visible, écriture et mimesis, le mode scripturaire et le mode plastique, entre plan et volume. En conséquence le travail n'est pas muet; il est épigraphique, comme il est disert et loquace, entre deux champs sémiotiques distincts, discursif et didactique, démonstratif et expositoire.

Une oeuvre livresque comme *Index* (1993) montre le langage imprimé comme inventaire et comme objet. On peut faire confiance à Carr-Harris de savoir que ces objets à ce format sont des *codex*, des *codices*, comme on les nommait avant de les appeler des livres et que leur étymologie les associe à l'idée de *tablette à écrire*. *Index* est alors littéralement un empilement: tables de matières tassées sur tables alphabétiques sur une petite table pliante et kitsch (cf. aussi la série *Tafel*; Tafel: *planche* ou *table* en allemand). Par delà, comme avec les oeuvres encyclopédiques issues d'une époque connue comme celle des *Lumières*, ce sont des entreprises de compréhension du monde. Instruments d'instruction dans la poursuite de la vérité, ils feraient le tour du savoir en un cercle complet (*encyclo-paedia*, *cyclo-paedia*, *macro-paedia*). Dans leur attitude et leur idéologie, comme dans leur portée, ce sont des projets universalistes et unitaristes, positivistes et progressistes,

des tentatives d'ordonnancement du monde par répertoire, classement, archivage, classification, catégorie, rubrique, sujet, référence. Comme la camera obscura, ce sont encore des lectures du monde à distance, non pas des expériences directes de celui-ci; des façons et des volontés de décrire le monde, le dire et le relater sans l'expérimenter (cf. *After Dürer*, à titre du langage, et l'involution de la reprise par Carr-Harris des gravures perspectivistes de Dürer, comment tout y est ou presque — sujet, écran, plan de calque; Dürer n'avait jamais vu de rhinocéros, il en avait seulement entendu parlé, avait uniquement entendu des descriptions; Dürer ne représente pas son expérience directe du monde dans ces gravures, celle d'un luth sur une table ou d'une femme allongée devant lui, mais explicite le calcul distant de son regard à travers de la vitre quadrillée).

Sans presque y toucher, Carr-Harris déjoue cet agencement du monde selon un ordre. D'un geste de la main, *Index* est désorganisé, installé sans ordre, n'en a jamais eu et n'aurait jamais eu raison à en avoir, le même libellé imprimé sur la couverture ou sur la tranche des livres se référant et montrant du doigt autant de choses différentes qu'il y a de volumes sur la table de cartes. Il y a des failles dans le système, des plis dans la méthode, de l'arbitraire, des conjonctions comme des disjonctions, ne serait-ce que dans l'ordre alphabétique; dans *Narcissus*, on voit que le même mot a plusieurs sens; dans *E (Encyclopedia Britannica)* que la même lettre a plusieurs entrées sans rapport les unes avec les autres. Il y a des retards et des délais à retardement aussi dans la description du monde; sans parler d'idéologie quant aux peuples et aux pays, dans les *Tafel* la typographie gothique date l'ouvrage, un indice d'origine et qui le situe comme étant d'époque, démodé, en décalage avec ce que l'on imprimerait aujourd'hui, comme l'iconographie le fait pour *In the Pacific Islands* (1992). Les archives sont instables, elles vieillissent, le temps s'écoule.

Chez Carr-Harris, le langage est imprimé à la machine comme il est également donné écrit à la main. Dans des oeuvres comme *Molly* (2002) et la série *Language* (2001), comme au-dessus des pièces livresques, il reprend une *main cursive*. Cette écriture est un autre recours à rebondissements et à recul; c'est une paléographie à l'huile ou à fil d'aluminium, une *main courante* et une ré-écriture à la façon d'autrefois, lorsque l'on apprenait à écrire à l'école de manière collective, normative et institutionnelle, à la craie sur tablettes ou au tableau noir. De surcroît, les manuscrits sur des ardoises d'écolier de *Language* s'en prennent au langage sous ses éléments fondamentaux d'organisation et de systématisation grammaticales, des formes et des classifications majeures du discours que sont *nom*, *verbe*, *gérondif*... comme à l'époque où l'on n'apprenait pas uniquement à écrire, mais aussi à lire et à dire.

--
le temps d'Annabel à Lolita
--

Comme on le voit, ce temps écoulé chez Carr-Harris, cette époque révolue et datée, n'est pas forcément historique et événementiel, n'est pas seulement celui des grands hommes (cf. au contraire des oeuvres des années 1970 qui se référaient à Alexandre, César, Louis XIV). La succédanéité et la simultanéité ne sont pas exclusives l'une de l'autre, le temps n'est pas l'histoire, mais il est historié, comme le langage est ici figuré. C'est un temps multiple, aussi personnel, individuel et subjectif, une chronologie plurielle, inconsciente et intérieure, pas obligatoirement linéaire, pouvant être cyclique

et récurrent, achronique et anachronique par la mémoire; le temps, il n'y a pas si longtemps, de l'enfance et de la jeunesse (et de la pédagogie que rappelle le didactisme de ce travail).

Ce qui explique pour partie les deux citations littéraires que sont *Molly* et *Annabel*, l'une écrite, l'autre récitée. A la façon de Pierre Ménard, le personnage de Borges qui prétendait écrire un nouveau *Don Quichotte* alors qu'il ne faisait que produire une réplique exacte mot pour mot de l'original, la première citation est une reprise du dernier monologue de Molly Bloom dans L'Ulysses de Joyce. L'oeuvre retrace à la main le passage de la fin du monologue intérieur, qui produit dans le désordre du passé dans le présent, où Molly, sans ponctuation et guère de syntaxe, laisse libre cours au flot de ses pensées, au flux de sa conscience, et, se revoyant jeune, revit ses amants et ses infidélités, et où par association elle se retrouve ailleurs qu'à Dublin, à Ronda, à Algeciras et à Gibraltar. Ponctué qu'il est de rythmiques affirmations répétées de consentement sexuel, ce choix d'exergue est de nouveau une affaire d'empilement, d'apparition, de disparition, de reflets et de retour de spectres, Joyce ayant originé et bâti son récit irlandais sur des correspondances homériques: Ithaque est projeté sur Dublin, Circé est la patronne d'un bordel, les épisodes de vingt ans d'odyssée sont télescopés dans la seule journée particulière du jeudi 16 juin 1904.

Il en est de même dans *Annabel*, où une voix monotone et anonyme dit certains passages de *Lolita*. C'est un récital, au sens de diction à haute voix, de citation de mémoire et de vive voix. Dans cette pièce audio-aurale, c'est encore une affaire de relecture et de distance interposée, par la numérisation qui gomme l'accent et dépersonnalise l'inflexion de la voix, de nouveau une question d'enregistrement, de reproduction et de projection et qui nous implique dans son fonctionnement puisque c'est à nous de la mettre en marche. La voix neutre et abstraite cite les passages du début du récit où Humbert Humbert se rappelle le premier accroc dans la linéarité du temps et de l'espace de sa vie, de l'été lointain de son adolescence quand commença à s'ouvrir la faille dans sa vie et qu'il aima Annabel: *Lolita commença avec Annabel*, comme il le dit, une autre avait précédée Lolita; il aime Lolita pour avoir tant aimé d'abord et ailleurs Annabel, qui le hante depuis et que réincarne beaucoup plus tard Lolita. L'intervalle de temps de l'une à l'autre dans cette histoire d'un seul amour, singulier et double, est de vingt-quatre ans.

Ian Carr-Harris

Lectures

E. H. Gombrich, *Ombres Portées*, 1995

Sarah Kofman, *Camera Obscura, de l'idéologie*, 1973

Roberto Casati, *La découverte de l'ombre*, 2002

Michel Nuridsany, *Dialogues de l'ombre, 1997*

Dominique Païni, Hubert Damisch, Michel Frizot, et al. *Projections, les transports de l'image*, 1997

Michel Frontisi, *L'image prise aux mots*, article in *Artstudio*, n° 15, hiver 1989

Gérard Genette, *Palimpsestes, la littérature au second degré*, 1982

Pierre Descargues, *Traités de perspective*, 1976

Octavio Paz, *Conjunciones y disyunciones*, 1969

Counters
- -
Tables
- -
Shelves
- -
Cabinets
- -
Books
- -
Blackboards
- -
Light
- -
Audio

1 - (900) 999-6969, 1991
plywood, plastic laminate, magazine
107 x 175 x 85 cm

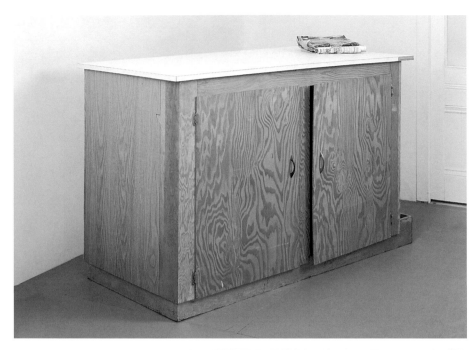

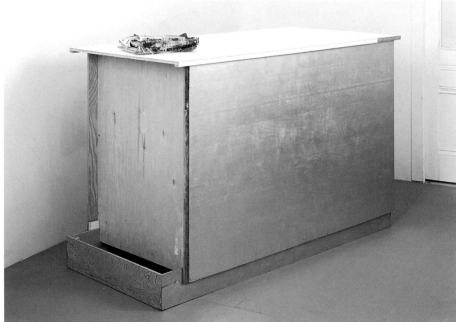

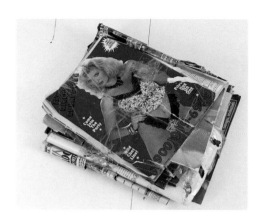

Jan. – Mar., 1993
wood with plastic laminate, aluminum frame, magazines
139 x 243 x 122 cm

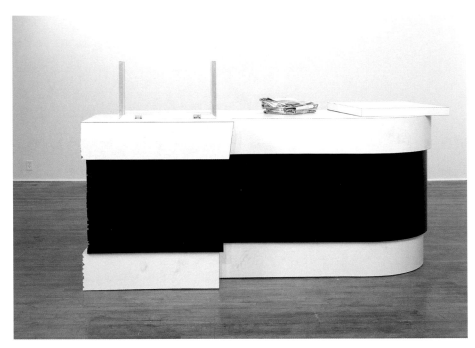

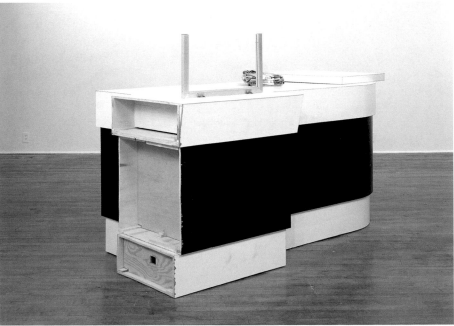

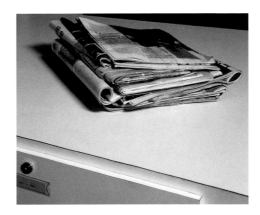

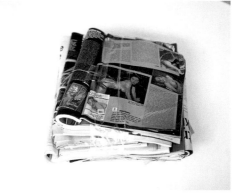

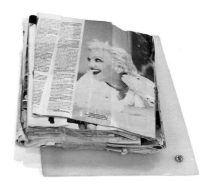

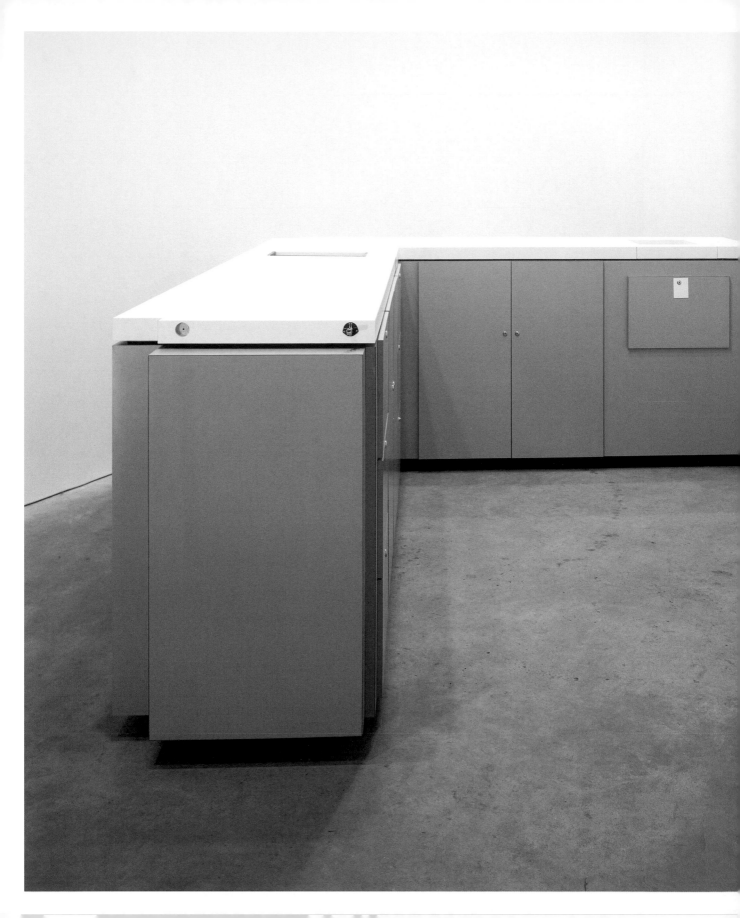

Work Station (1), 1995
wood, Arborite, hardware
100 x 400 x 500 cm

39

Index, 1993
portable card table, books
77 x 81.3 x 81.3 cm

41

Temperature – Temple, 1993
case, back-lit book, glass, magazine
85 x 149 x 75 cm

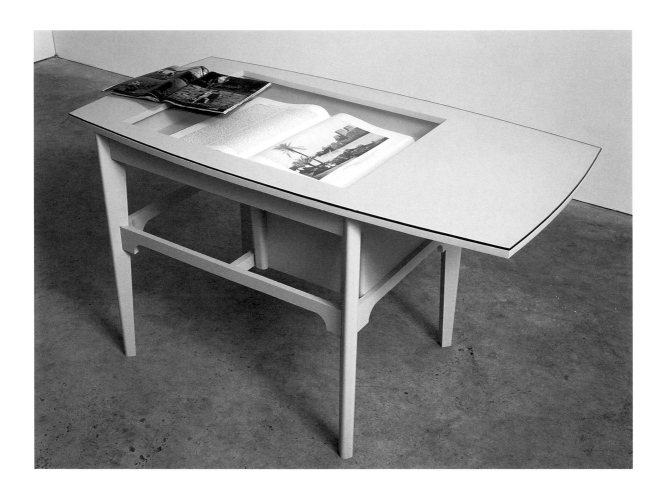

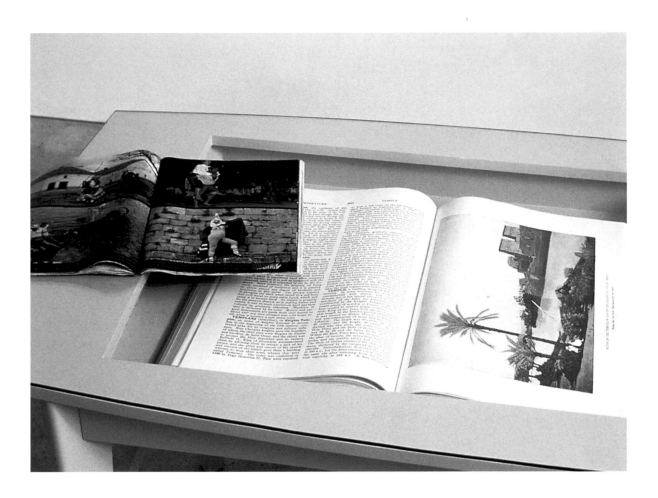

Narcissus, 1994
wood with plastic laminate, glass, back-lit book, fluorescent lights
100 x 123.5 x 83 cm

44

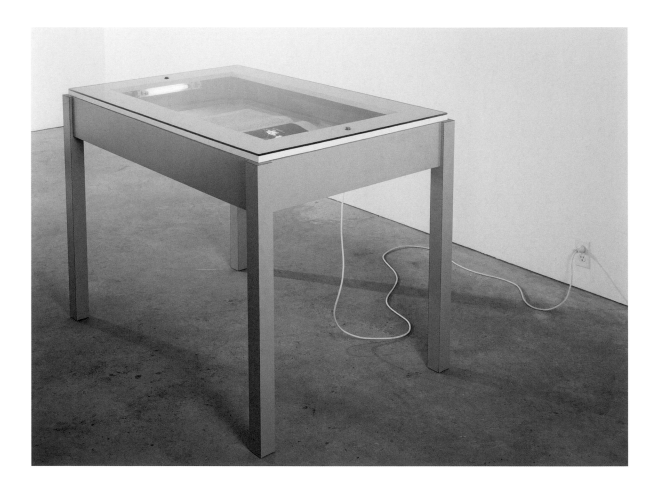

704 NARCISSUS

with the jam. Or, if it eats too much, and is of the proper grade of intelligence, it may associate unpleasant feelings with jam. At any rate there is here a projection (see MECHANISMS, MENTAL) of the really subjective pleasure or pain feeling, which is thereby attributed to the jam as a quality which jam uniformly has. This process, which is psychological, but not logical, is the same as that carried out when the child forms a concept of another person. Therefore the concept of this other person that itself is made up of feelings which really belong to the child but which it irrationally attributes to other persons.

The intermediate transitional stage in the development is where the individual not merely regards his own body as a source of gratification (pure erotism) but with absolute naïveté looks upon his own personality or some other which he identifies with himself in the same light as he will later regard the true object love. That is, the autoerotic satisfaction comes from an exercise of the child's own body on itself or, as is seen in day-dreaming, or romancing of almost any kind, from an exercise of its own mind with its own mental material, uncorrelated with external reality. In the Narcissistic stage of the development of the human psyche the young person shifts from a crassly subjective form of gratification of the libido to a more objective form, without, however, realizing the actual differences between the projections of his own mind and the concrete facts of the characters of other people. The narcissistic youth finds some other person to love, but naïvely endows that other with his own qualities, not making, or perhaps not able to make, the necessary discriminations between what he thinks the other is and what the other really is. Thus a young person will find some other personality attractive and suppose that because some elements of the other are agreeable, the rest of the elements are so, and be very much disturbed, if not disordered, at the occasional outcroppings of uncongenial traits. Just as in the legend of Narcissus, who is fabled to have fallen in love with his own reflection which he perchance saw in a pool, and later to have pined away in ungratified desire for the being he saw but could never touch, so the ordinary person of to-day may, through constitution or lack of proper training, become a modern Narcissus, who desires merely the gratification of his projected unconscious wishes. He thinks his own thoughts will be given external reality simply by wishing for it, either unable or unwilling to see the discrepancy between his essentially autoerotic desires and the actual nature of external reality. The average child is taught by experience to derive satisfaction from exerting the limit of his ability upon external reality in order to make it conform to his wishes, and to take so much pleasure from the exertion that there will be no pain from the necessary disappointment of his wishes. This the fabled Narcissus never did, but tried again and again to embrace the beautiful being in the pool, where the average youth would have seen the impracticability of such action.

The subject of Narcissism is extremely important in the modern analytical explanation of the mental disease paranoia. In this disease, which is characterized by a systematized suspicion and delusion of persecution, the subject takes unconsciously and crystallizes the attitude expressed by Narcissism. The process of mental development which shows how vitally important in the next and last step to adult the psyche is the somewhat as follows. The may be outlined various phases of the situation have been illustrated by the development of "I love him," supposing the simple statement, that the subject is for the sake of the idea represented by the sentence is a male. If the idea represented by the sentence is followed out in real life, there results a more or less veiled homosexuality and that lack of adaptation of the individual to external reality is foi so great as if the idea "I love him is completely repressed into the unconscious. The idea "I love him" is thus repressed, is always however, particularly if thus repressed, is always inevitably transformed, by virtue of the principle of *ambivalence* into "I hate him," and the inference from that is readily made to "He hates me," which is the basis on which this type of paranoid trend is built. Men who have this buried homosexuality in their unconscious are helpless without analysis, because they do not know of the existence of it and can never find it themselves. Therefore persons who are unduly suspicious of those around them have frequently the germ of a very serious mental disease, the cure of which requires a very special technique and the prevention of which would be of the utmost importance. Narcissism is thus seen to be an unconscious subjective homosexuality, differing from other forms of autoerotism in being applicable only to the whole individuality instead of to parts of it, and by reason of its total applicability being the cause of the tendencies which, when allowed to become extreme, lead to paranoia or paranoid states, as well as to alcoholism and various drug addictions. Consult Jelliffe and White, 'Diseases of the Human System' (1917).

NARCISSUS, när-sĭs'ŭs, in Greek mythology, the son of the river god Cephissus. Narcissus was of surpassing beauty, but excessively vain and inaccessible to the feeling of love. Echo pined away to a mere voice because her love for him found no return. Nemesis determined to punish him for his coldness of heart, and caused him to drink at a certain fountain, wherein he saw his own image, and was seized with a passion for himself of which he pined away. The gods transformed him into the flower which still bears his name. See ECHO; MYTHOLOGY.

NARCISSUS, a genus of plants of the order *Amaryllideæ* (q.v.). The species, numbering from 16 to about 50, according to different authors, have bulbous roots, narrow grass-like leaves, and generally white or yellow flowers borne singly or in small clusters and protruding from a dry spathe at the summit of a leafless scape. Because of their hardiness, ease of cultivation, habit of blooming in early spring, beauty and fragrance, many of the species and their numerous hybrids and varieties have been general garden favorites for centuries. A few produce their blossoms in the autumn (for example, *N. serotinus*, *N. ele-*

NARCISSUS

Rozenstraat 8 (part two), 1995
metal card table with plasticized surface, reading lamp, back-lit book
100 x 75 x 75 cm

46

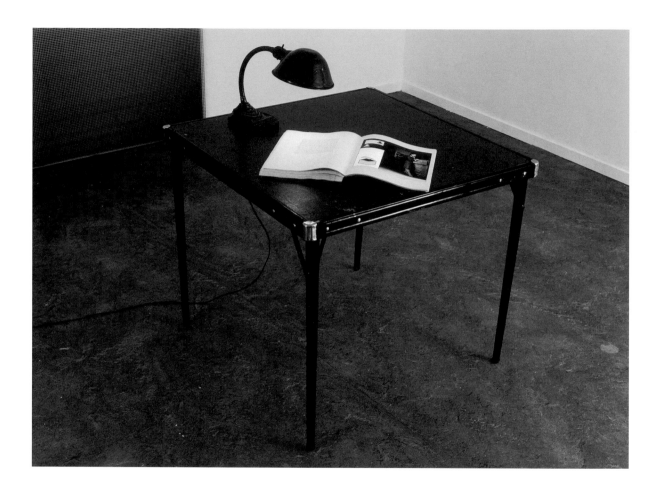

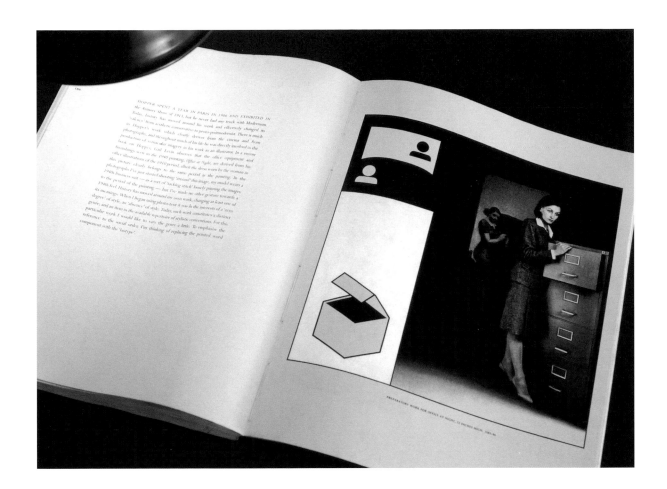

In the Pacific Islands, 1992
steel shelving, back-lit book
122 x 78 x 25 cm

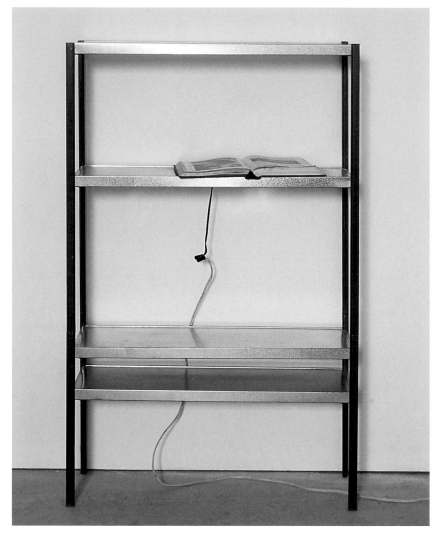

Shelving Unit, 1995
wood, Arborite, metal
252 x 671 x 71 cm

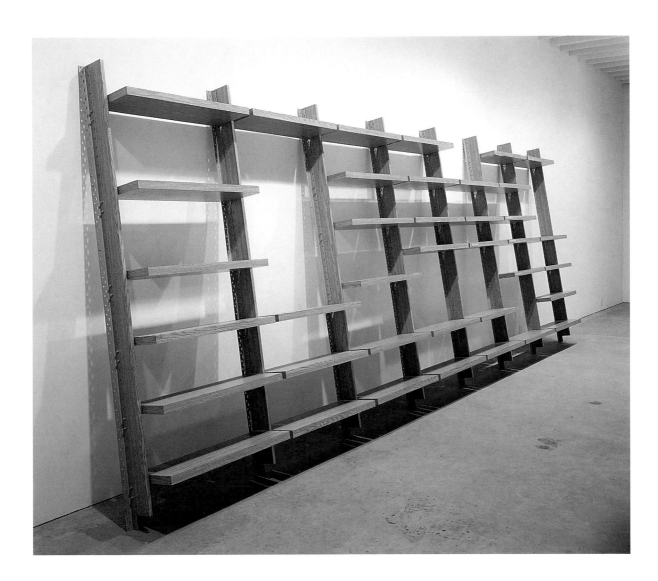

Made in Hong Kong, 1993
wood with plastic laminate, books, two painted statuettes
272 x 500 x 47 cm

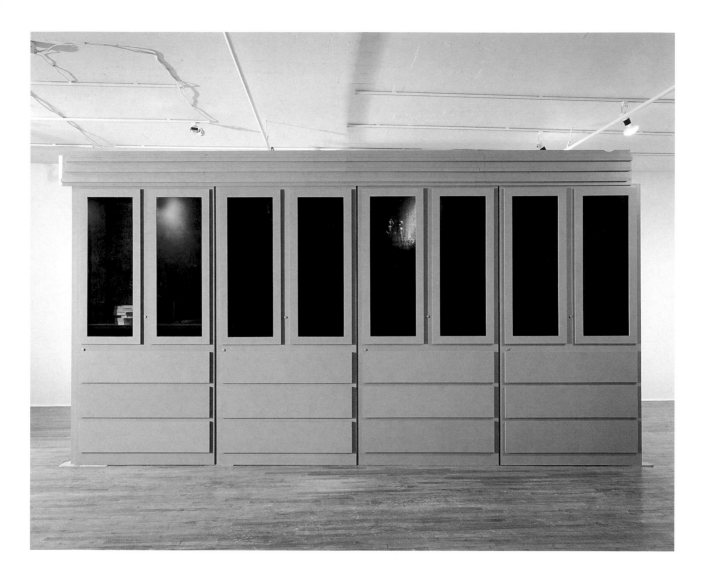

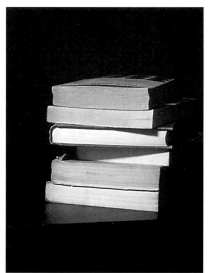

audio/visual station, 1995
metal, plywood, plastic laminate
180 x 101 x 73 cm

52

Cabinets

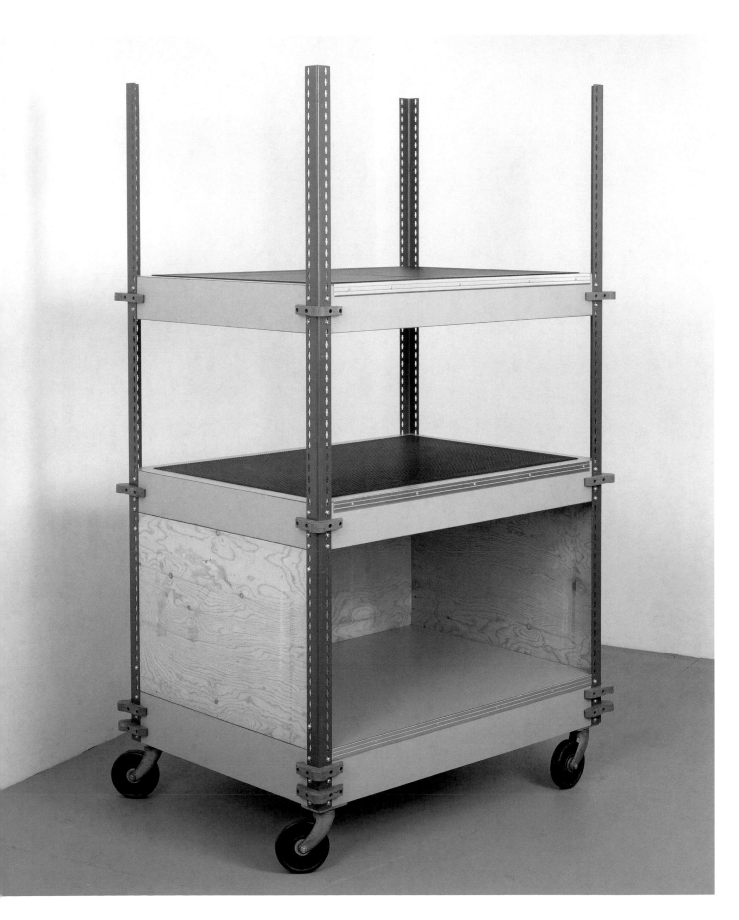

annuity, 1995– (from **Books of Knowledge**)
three back-lit books, aluminum
each 27.5 x 40 x 5 cm

fire ship, 1995– (from **Books of Knowledge)**
three back-lit books, aluminum
each 27.5 x 40 x 5 cm

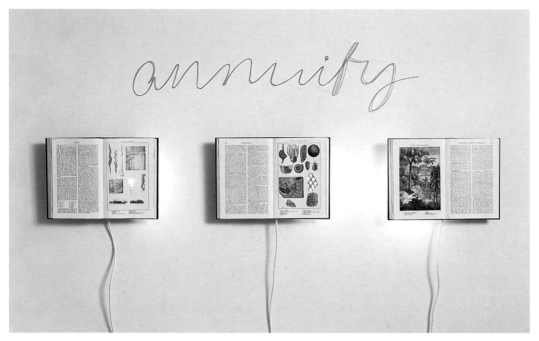

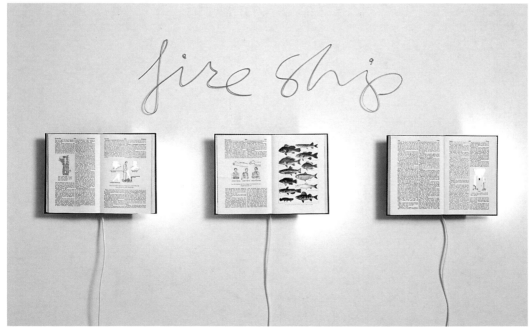

plant life, 1995– (from **Books of Knowledge)**
three back-lit books, aluminum
each 27.5 x 40 x 5 cm
Collection of Christian Keesee

Roosevelt, 1996– (from **Books of Knowledge)**
three back-lit books, aluminum
each 27.5 x 40 x 5 cm
collection of McArthur Reford family

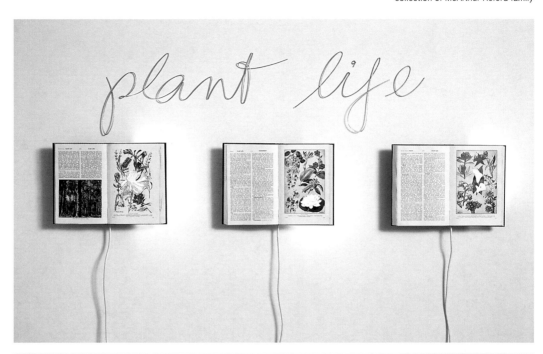

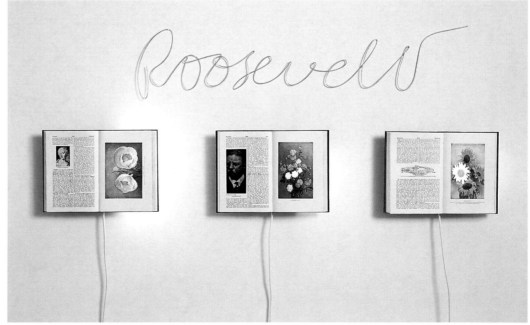

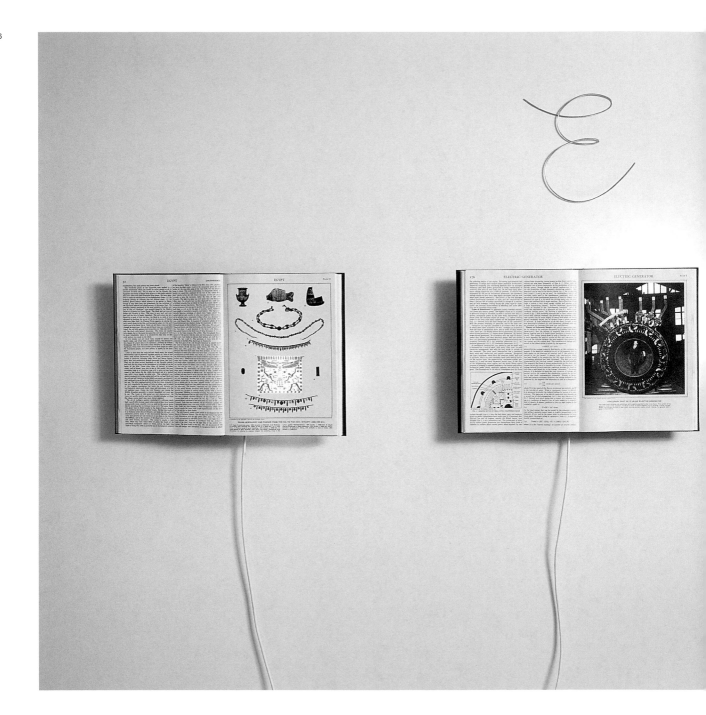

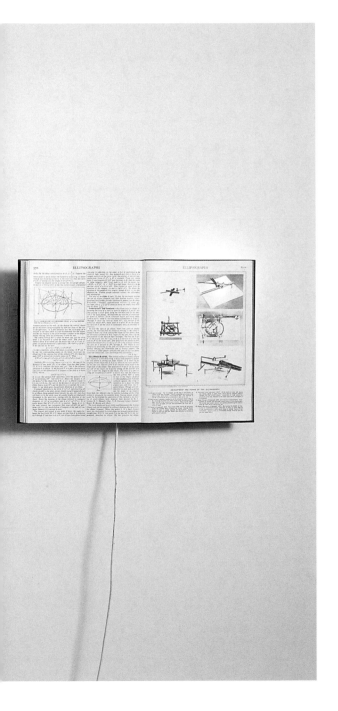

Chinese, 1997 (from **Pays et Nations/Peoples and Places**)
back-lit book, aluminum
195 x 55 x 8 cm

acteur, 1997 (from **Pays et Nations/Peoples and Places**)
back-lit book, aluminum
195 x 41 x 8 cm

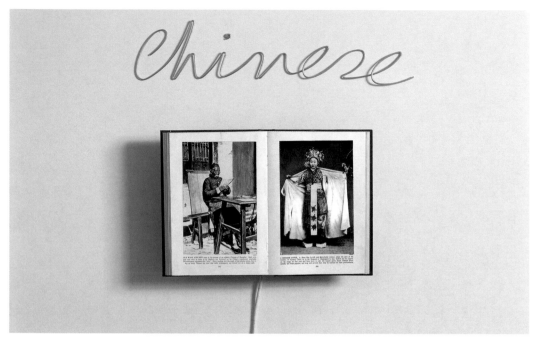

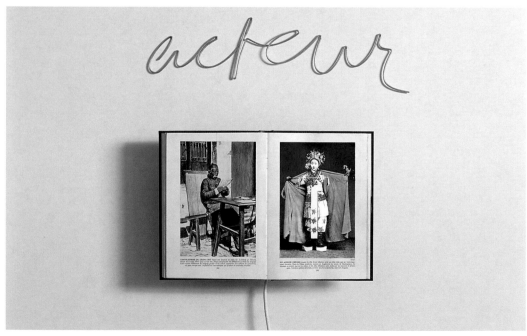

siamese, 1997 (from **Pays et Nations/Peoples and Places)**
back-lit book, aluminum
195 x 70 x 8 cm

drame, 1997 (from **Pays et Nations/Peoples and Places)**
back-lit book, aluminum
195 x 55 x 8 cm

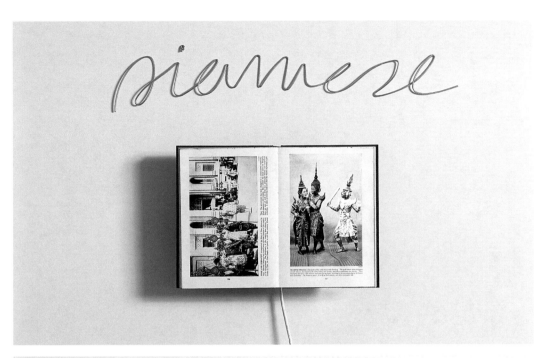

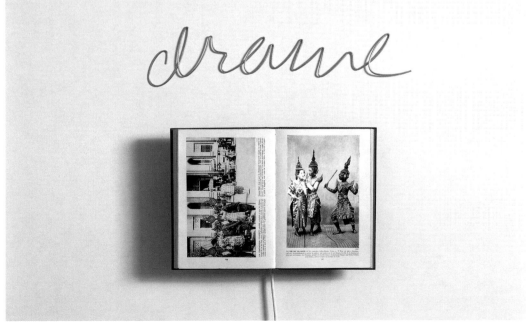

Tafel 3, 1999
back-lit book, aluminum
195 x 56 x 8 cm

Tafel 9, 1999
back-lit book, aluminum
195 x 56 x 8 cm

Tafel 31, 1999
back-lit book, aluminum
195 x 56 x 8 cm

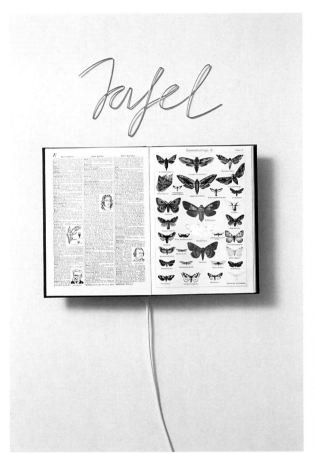

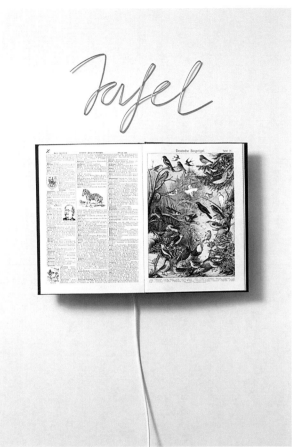

Seven Deadly Sins, 1997
fixed chalk on chalkboard, wood
each 31 x 42 cm; edition of three
Collection of McCarthy Tétrault, Toronto

62

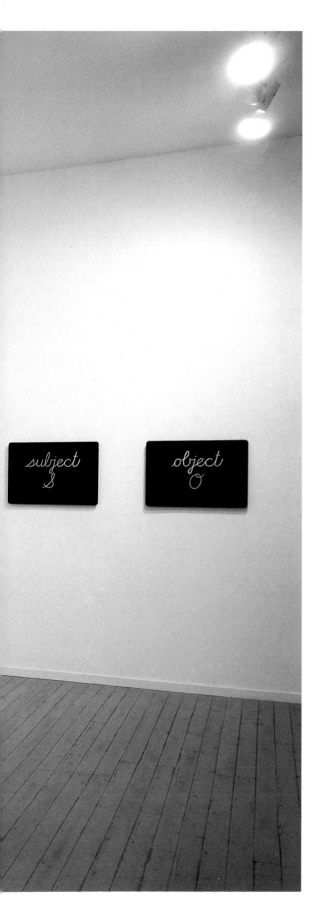

Writing (language series), 2001
oil on chalkboard
each 45.5 x 63 cm

Blackboards

Flower of the mountain yes when I put t

used or shall I wear a red yes and h

and I thought well as well him as an

to ask again yes and then he asked

flower and first I put my arms arou

he could feel my breasts all perfume yes

I said yes I will Yes

Molly, 2002
oil on chalkboard, lights
122 x 472.8 x 10 cm

se in my hair like the Andalusian girls
e kissed me under the Moorish wall
and then I asked him with my eyes
ould I *yes* to say *yes* my mountain
m *yes* and drew him down to me so
is heart was going like mad and *yes*

137 Tecumseth, 1994
projection unit with motor
427 x 330 x 1490 cm variable
Collection of the National Gallery of Canada, Ottawa
Installation at Susan Hobbs Gallery, Toronto

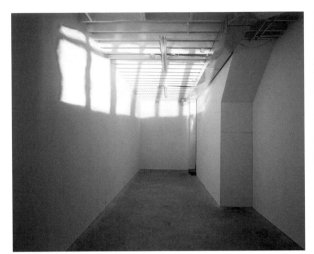
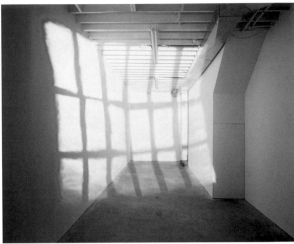

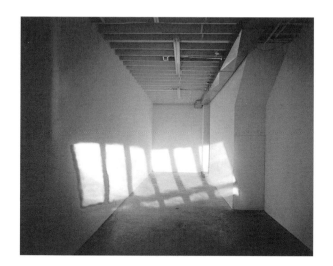

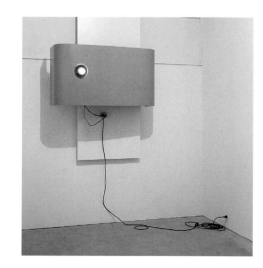

Rozenstraat 8 (part one), 1995
projection unit with motor
125 x 75 x 100 cm
Installation at proton ICA, Amsterdam

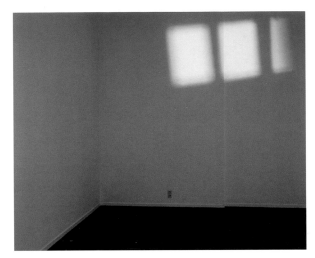
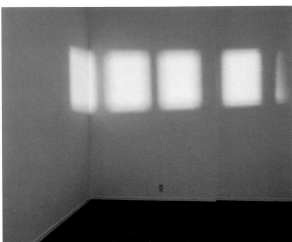

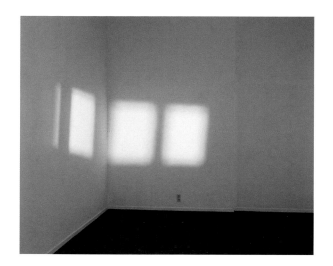 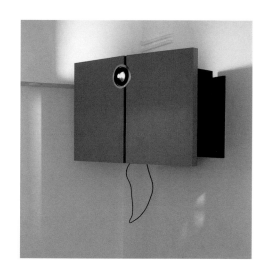

231 Queens Quay, 1998
projection unit with motor
variable dimensions
Installation at The Power Plant, Toronto

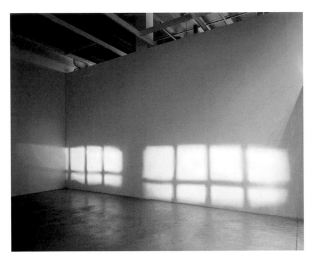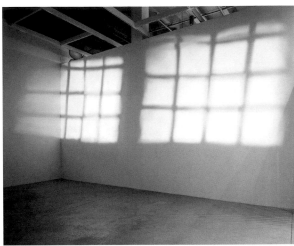

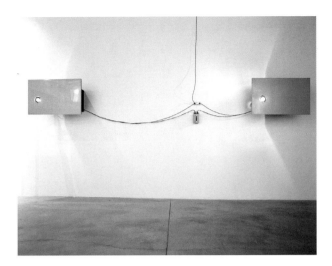

2, rue des deux Moulins, 1998
projection unit with motor
variable dimensions
Installation at Susan Hobbs Gallery, Toronto

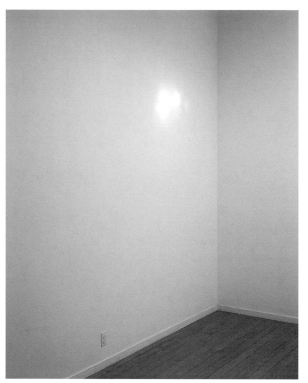
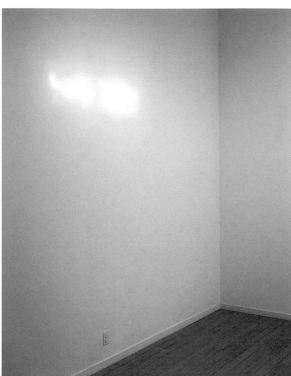

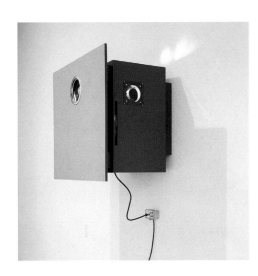

8, rue Ferrand, 2002
projection unit with motor
variable dimensions
Installation at The Power Plant, Toronto

76

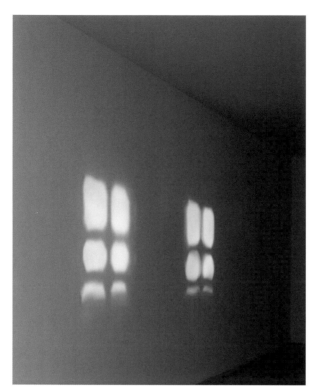
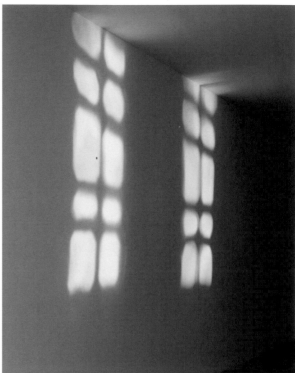

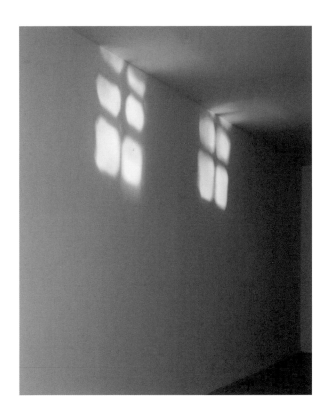

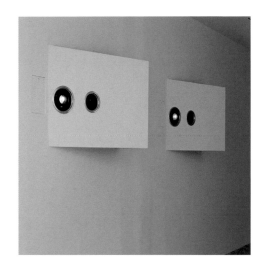

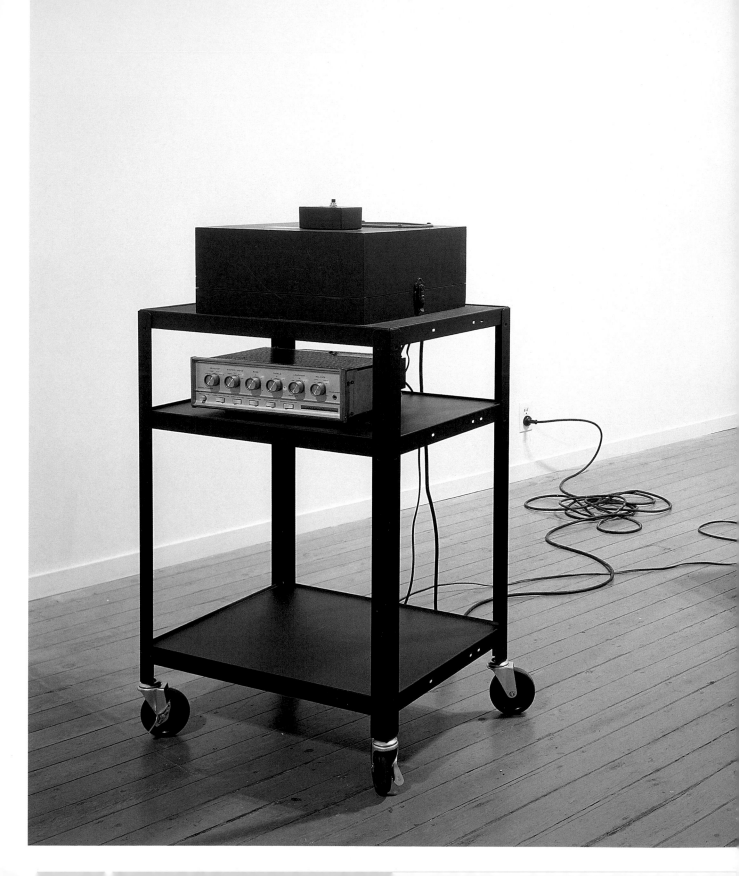

Annabel, 1999
metal a/v cart, floor speaker, audio
100 x 200 x 105 cm

79

Biography

Ian Carr-Harris was born in Victoria, British Columbia, in 1941.
In 1963, he received an Hons. B.A. from Queen's University in
Kingston, Ontario, and in 1964 he received a B.L.Sc. from the
University of Toronto. From 1969 to 1971, Ian Carr-Harris studied
at the Ontario College of Art, where he received his A.O.C.A.
He lives and works in Toronto.

Solo Exhibitions

2002	The Power Plant, Toronto
–	Josselyne Naef Art Contemporain, Montréal
–	Susan Hobbs Gallery, Toronto
2001	Susan Hobbs Gallery, Toronto
1999	Centre culturel canadien, Paris
–	Galerie Josselyne Naef, Lyon
–	*137 Tecumseth*, National Gallery of Canada, Ottawa
–	Susan Hobbs Gallery, Toronto
1998	Susan Hobbs Gallery, Toronto
1996	Susan Hobbs Gallery, Toronto
–	Galeria Carles Poy, Barcelona
–	*Books for a Public Library*, Southern Alberta Art Gallery, Lethbridge; travelled to Owens Art Gallery, Sackville; Oakville Galleries, Oakville (1997); Art Gallery of Newfoundland and Labrador, St. John's; London Regional Art and Historical Museum, London; Leonard & Bina Ellen Art Gallery, Montréal (1998); Dunlop Art Gallery, Regina (1999)
–	Galeria & Ediciones, Madrid
1995	École des Beaux-Arts, Metz
–	*Furnishing the Office*, proton ICA, Amsterdam
–	L'Aquarium, Valenciennes
1994	*Pages from History*, Oakville Galleries, Oakville
–	Galerie Optica, Montréal
–	Villa Arson, Nice
–	Galeria Carles Poy, Barcelona
–	Susan Hobbs Gallery, Toronto
–	Centre d'art contemporain, Herblay
1993	Susan Hobbs Gallery, Toronto
–	Carmen Lamanna Gallery, Toronto
1991	Carmen Lamanna Gallery, Toronto
1989	*Ian Carr-Harris 1971–1977*, Art Gallery of Ontario, Toronto
–	Agnes Etherington Art Centre, Queen's University, Kingston
1988	London Regional Art Gallery, London
1987	Carmen Lamanna Gallery, Toronto
1986	Carmen Lamanna Gallery, Toronto
1985	Carmen Lamanna Gallery, Toronto
1984	Carmen Lamanna Gallery, Toronto
1983	49th Parallel, New York
1982	*Recent Work: Ian Carr-Harris*, Dalhousie Art Gallery, Halifax
–	The Gallery, Scarborough College, Toronto
1981	Carmen Lamanna Gallery, Toronto
	Yajima/Galerie, Montréal
1979	Carmen Lamanna Gallery, Toronto
1977	Carmen Lamanna Gallery, Toronto
1975	Carmen Lamanna Gallery, Toronto
1973	Carmen Lamanna Gallery, Toronto
1972	Nova Scotia College of Art and Design, Halifax
–	Carmen Lamanna Gallery, Toronto
1971	A Space, Toronto

82

Selected Group Exhibitions

2001 *Canadian Stories*, Ydessa Hendeles Art Foundation, Toronto
1999 *Musiques en Scène*, Musée d'art contemporain de Lyon
1998 *Re:presentation*, Freedman Gallery, Reading
– *La Biennale de Montréal*, Centre international d'art contemporain, Montréal
– *Threshold*, The Power Plant, Toronto
1997 *En Cause: Brancusi*, Axe Neo-7 art contemporain, Hull
1996 *Love Gasoline*, Mercer Union, Toronto
1995 *Barbara Bloom, Ian Carr-Harris, John Massey*, S. L. Simpson Gallery, Toronto
1994 *W139*, Amsterdam
1993 *Visual Evidence*, Dunlop Art Gallery, Regina
1992 *A Tribute to Carmen Lamanna*, National Gallery of Canada, Ottawa
1991 *A Tribute to Eva Hesse's Gift to Sol LeWitt*, Axe Neo-7 art contemporain, Hull
– *Union Language*, Mercer Union, Toronto
1990 *Media/Culture/Art*, Mackenzie Art Gallery, Regina/C magazine, Toronto
– *Trans-Positions*, Public Transit System, Vancouver
– *The 8th Biennale of Sydney*, Art Gallery of New South Wales, Sydney
1989 *Rooms with a View*, Edmonton Art Gallery, Edmonton
– *Canadian Biennial of Contemporary Art*, National Gallery of Canada, Ottawa
1988 *Structures of Desire*, Gallery 76, Toronto
1987 *Toronto: A Play of History (Jeu d'histoire)*, The Power Plant, Toronto
– *Documenta 8*, Museum Fridericianum, Kassel
1986 *Luminous Sites*, Western Front and Video Inn, Vancouver
– *Focus, Kanadische Kunst von 1960–1985*, Internationaler Kunstmarkt, Cologne
1985 *Aurora Borealis*, Centre international d'art contemporain, Montréal
1984 *Reflections: contemporary art since 1964*, National Gallery of Canada, Ottawa
– *Art and Audience*, Art Gallery of Northumberland, Cobourg
– *XLI Biennale di Venezia*, Venice
– *Vestiges of Empire*, Camden Art Centre, London
1983 *From Object to Reference*, Carmen Lamanna Gallery, Toronto
1982 *Fiction*, Art Gallery of Ontario, Toronto; travelled to Art Gallery of Windsor, Windsor; Glenbow Museum, Calgary; Mendal Art Gallery, Saskatoon; Laurentian University Museum and Art Centre, Sudbury; Agnes Etherington Art Centre, Kingston; 49th Parallel, New York.
– *Drawings by Contemporary Sculptors*, Surrey Art Gallery, Surrey; travelled to University of Lethbridge Art Gallery, Lethbridge; London Regional Art Gallery, London; Dalhousie Art Gallery, Halifax; Sir George Williams Art Gallery, Montréal.
1981 *Canada in Birmingham*, Ikon Gallery, Birmingham
– *Realism: structure & illusion*, Macdonald Stewart Art Centre, Guelph
1980 *11th International Sculpture Conference*, Washington, D.C.
1979 *Confrontations*, Vancouver Art Gallery, Vancouver
1978 *Kanadische Kunstler*, Kunsthalle, Basel
– *Another Dimension II*, Vancouver Art Gallery, Vancouver; travelled to Alberta College of Art, Alberta; Southern Alberta Art Gallery, Lethbridge; London Regional Art Gallery, London.
1977 *Another Dimension*, National Gallery of Canada, Ottawa

1976 *Ontario Now: A Survey of Contemporary Art*, Kitchener-Waterloo Art Gallery, Kitchener; travelled to Art Gallery of Hamilton, Hamilton.
1975 *Carmen Lamanna Gallery at the Owens Art Gallery*, Mount Allison University, Sackville
– *Carmen Lamanna Gallery at the Canadian Cultural Centre*, Centre culturel canadien, Paris
1974 *9ᵉ Biennale de Paris*, Musée d'art moderne de la ville de Paris
– *Investigations*, Mount Allison University, Sackville
– *Contemporary Ontario Art*, Art Gallery of Ontario, Toronto
1973 *Canadian Trajectories '73*, Musée d'art moderne de la ville de Paris
1972 Agnes Etherington Art Centre, Kingston
1970 *Ian Carr-Harris and Stephen Cruise*, Nightingale Gallery, Toronto
– *Concept 70*, Nightingale Gallery, Toronto

Ian Carr-Harris

Selected Bibliography

Periodicals

- Allsopp, Judith. "Ian Carr-Harris at Carmen Lamanna." *Artists Review* 1 (November 1977): 5–6.
- Dagenais, Francine. "Claire Savoie and Ian Carr-Harris." *C Magazine* 42 (summer 1994): 54–55.
- Dault, Gary Michael. "Ian Carr-Harris: Carmen Lamanna Gallery." *Artscanada* 32 (winter 1975–76): 53.
- Feinstein, Roni. "Report from Toronto: Canada's Art Capital: The Public Sector." *Art in America* no. 7 (July 1994): 34–43.
- Fleming, Martha. "Ian Carr-Harris: Yajima Gallery." *Vanguard* 10 (December/January 1981–82): 41.
- Hakim, Mona. "Ian Carr-Harris, Optica." *Le Devoir* 5–6 (February 1994).
- Keziere, Russell. "Reckonings: Ian Carr-Harris." *Vanguard* 16 (December–January 1987–88): 25–29.
- MacMillan, Laurel. "Ian Carr-Harris/Mark Schilling." *Canadian Art*.18, no. 4, (winter 2001): 80–82.
- McGrath, Patrick. "Ian Carr-Harris: Carmen Lamanna Gallery." *Vanguard* 10 (summer 1981): 44–45.
- Monk, Philip. "Staging Language and Representing History: Ian Carr-Harris." *Vanguard* 12 (November 1983): 18–21. Reprinted as "Staging Language, Presenting Events, Representing History: Ian Carr-Harris." September 1973," in Philip Monk, *Struggles with the Image: Essays in Art Criticism*. Toronto: YYZ Books, 1988.
- ———. "Ian Carr-Harris." *Parachute*, no. 39 (June–August 1985): 68–69.
- Murchie, John. "Ian Carr-Harris: Interview." *Criteria* 4 (spring 1978): 7–9.
- Nasgaard, Roald. "Toronto." *Artscanada* 30 (December–January 1973–74): 193–97.
- Nemiroff, Diana. "Ian Carr-Harris? A Demonstration: Yajima Gallery." *Parachute* 25 (winter 1981): 24.
- Rhodes, Richard. "Democratiser." *C Magazine* (spring 1989): 35–39.
- Ritchie, Christina. "Ian Carr-Harris: Susan Hobbs Gallery." *Canadian Art* (spring 1995): 86.
- Rupic, Milan. "Ian Carr-Harris: Carmen Lamanna Gallery." *Artscanada* 36 (August–September 1979): 48.
- Santi, Tiziano. "Ian Carr-Harris." *Juliet Art Magazine* 40 (October–November 1990): 45.
- Sausset, Damien. "Ian Carr-Harris, Dürer et le rhinoceros." *L'Oeil*, March 1999.

Exhibition Catalogues and Publications

- Ammann, Jean-Christophe. *Kanadische Künstler*. Basel, Switzerland: Kunsthalle Basel, 1978.
- Augaitis, D., and K. Henry. *Luminous Sites*. Vancouver: Video Inn & Western Front, 1986.
- Bell Farrell, Carolyn. *Pages from History: Ian Carr-Harris, Early Works*. Oakville: Oakville Galleries, 1993.
- Blouin, René, and Normand Thériault. *Aurora Borealis*. Montreal: Centre international d'art contemporain, 1985.
- Bradley, Jessica. *Ian Carr-Harris/Liz Magor: Canada, XLI Biennale di Venezia*. Ottawa: National Gallery of Canada, 1984.
- Burnett, David, and Marilyn Schiff. *Contemporary Art in Canada*. Edmonton: Hurtig, 1983.
- Cheetham, Mark. *Remembering Post-Modernism: Trends in Recent Canadian Art*. Toronto: OUP, 1991.
- Cummins, Louis, Clara Renau and Martine Needam. *Indices*. Herblay, France: Les Cahiers des Regards, Centre d'art contemporain, 1994.
- Dompierre, Louise. *Toronto: A Play of History (Jeu d'histoire)*. Toronto: The Power Plant, 1987.
- ———, Antonio Guzman and Timothy Murray. *Threshold*. Toronto: The Power Plant, 1998.
- Giroudon, James, and Thierry Raspail. *Musiques en Scène*. Lyon: Musée d'art contemporain de Lyon, 1999.
- Graham, Mayo. *Another Dimension*. Ottawa: National Gallery of Canada, 1977.
- Jenkner, Ingrid. *Visual Evidence*. Regina: Dunlop Art Gallery, 1993.
- Klepac, Walter. *Truth and Desire: The Illuminated Bookworks of Ian Carr-Harris*. Lethbridge, Alberta: Continuum, Southern Alberta Art Gallery, 1996.
- Milrod, Linda. *Ian Carr-Harris: Recent Work*. Halifax: Dalhousie University Art Gallery, 1982.
- Monk, Philip. *Ian Carr-Harris 1971–1977*. Toronto: Art Gallery of Ontario, 1988.
- Nemiroff, Diana. *Canadian Biennial of Contemporary Art*. Ottawa: National Gallery of Canada, 1990.
- Newlands, Anne. *Canadian Art: From Its Beginnings to 2000*. Toronto: Firefly Books, 2000.
- Pollock, Ann. *Confrontations*. Vancouver: Vancouver Art Gallery, 1979. Randolph, Jeanne, Jérôme Sans and Ian Carr-Harris. *Mouvance*.
- Toronto/Montréal: Susan Hobbs Gallery/Galerie Optica, 1995.
- Town, Elke. *Fiction: An Exhibition of Recent Work by Ian Carr-Harris, General Idea, Mary Janitch, Shirley Wiitasalo*. Toronto: Art Gallery of Ontario, 1982.
- ———. *Transpositions*. Vancouver: Active Artifacts Cultural Association, 1990.
- Youngs, Christopher, ed. "Ian Carr-Harris." *Documenta 8*. Vol. 2, Kassel, Germany, 1987.
- ———. *Re:presentation*. Reading, PA: Freedman Gallery, 1998.

Exhibition List

All works courtesy of the artist and Susan Hobbs Gallery, Toronto

After Dürer, 1989
cabinet, print, film loop, rear projection screen, 16 mm sound projector, speaker
variable dimensions

Made in Hong Kong, 1993
wood with plastic laminate, books, two painted statuettes
272 x 500 x 47 cm

Jan. – Mar., 1993
wood with plastic laminate, aluminum frame, magazines
139 x 243 x 122 cm

Index, 1993
portable card table, books
77 x 81.3 x 81.3 cm

Narcissus, 1994
wood with plastic laminate, glass, back-lit book, fluorescent lights
100 x 123.5 x 83 cm

Annabel, 1999
metal a/v cart, floor speaker, audio
100 x 200 x 105 cm

Molly, 2002
oil on chalkboard, lights
122 x 472.8 x 10 cm

8, rue Ferrand, 2002
projection unit with motor
variable dimensions

Ian Carr-Harris

Animateurs
Patrick Borjal
Astrid Bin
Dana Cowie
Joey Dubuc
Jenny Florence
Elaine Gaito
Natasha Lan
Lucia de L'Amour
Nick Ostoff
Sarah Paul
Chen Tamir
Alex Snukal

Exhibition Installation Crew
Neil Burns
Corinne Carlson
Sheila Dietrich
Julie Faris
Eric Glavin
Anitra Hamilton
Brad Johnson
Sean McQuay
Doug Moore
Mark Phillips

Publicity
Linda Liontis

Website
Jill Murray

Catalogue Acknowledgements

Edited by **Alison Reid**
Designed by **Andrew Di Rosa / SMALL**
Typeset by **Richard Hunt**
Printed in Canada by **St. Joseph Print Group, Ottawa**

All photographs courtesy of the **Susan Hobbs Gallery,** Toronto.
Photography: Photography by **Isaac Applebaum** (p. 38–45,
48–49, 52, 54–65, 68–69, 74–75, 78), **Ian Carr-Harris** (p. 51),
Yves Lacombe (p. 36–37, 50), **Cheryl O'Brien** (p. 8, 20, 34–35,
37, 53, 67, 72–73).

Acknowledgements

The Power Plant Contemporary Art Gallery at Harbourfront Centre
is a registered Canadian charitable organization supported by
Harbourfront Centre, the membership of The Power Plant, private
donations, the City of Toronto through the Toronto Arts Council,
the Ontario Arts Council and The Canada Council for the Arts.

--
The Power Plant Staff
--